POSTCARD HISTORY SERIES

Columbus, Georgia

IN VINTAGE POSTCARDS

This postcard was published in 1943 by Curt Teich & Co. of Chicago, a major national postcard publisher, for the White Company of Columbus. Within the letters are scenes from Columbus and Fort Benning.

POSTCARD HISTORY SERIES

Columbus, Georgia
IN VINTAGE POSTCARDS

Kenneth H. Thomas Jr.
co-sponsored by the Historic Columbus Foundation

ARCADIA

First published 2001
Reprinted 2001, 2002, 2003, 2004

Published by Arcadia Publishing
Charleston SC, Chicago IL, Portsmouth NH, San Francisco CA

Printed in Great Britain

Library of Congress Catalog Card Number: 2001089263

For all general information contact Arcadia Publishing at:
Telephone 843-853-2070
Fax 843-853-0044
E-mail sales@arcadiapublishing.com
For customer service and orders:
Toll-Free 1-888-313-2665

Visit us on the internet at http://www.arcadiapublishing.com

CONTENTS

ACKNOWLEDGMENTS

I could not have completed this book in the short, three months time in which I agreed to do it without the help, support, and enthusiasm of my mother, Louise Brooks Thomas.

A major boost for the book was the support and interest of Virginia Peebles, executive director of the Historic Columbus Foundation who secured their co-sponsorship of the book. My sister, Melissa, and her husband, Jim Thomas, have also lent encouragement to my efforts.

Besides my mother's research assistance, many others helped with the research involved in this effort and they are as follows: the W.C. Bradley Library Staff, Columbus State University Library and Archives staff (Dr. Craig Lloyd, Callie B. McGinnis, and Lewis O. Powell); the Curt Teich Postcard Company Archives in Lake County, Illinois; the Historic Chattahoochee Commission (Doug Purcell); Port Columbus Naval Museum (Bob Holcombe); and the Historic Preservation Division of the Georgia Department of Natural Resources, where I work as an historian with the National Register of Historic Places. Roger Harris provided editorial assistance.

Individuals who have assisted with research requests, their time, or their memories are as follows: Carrie Adamson, Dot Colbert, John B. Ellis, Biddy Barfield Hammett, Estelle Hinde, Jake Ivey, David M. Jones, Ed Kendust, Clason Kyle, John R. Lassiter, John Lupold, W. Marion Page, Frank Schnell, John M. Sheftall, David E. Smart, Gladys Sweatt, and John E. Wells.

I am also thankful for the publicity given the book by the *Columbus Ledger-Enquirer* and state editor Harry Franklin in his February 6, 2001 cover story, which helped get the word out to the community. I would not have heard from many of the people listed below without his help.

The majority of cards loaned to me were from Virginia Peebles on behalf of the Historic Columbus Foundation and Mike Helms, of Helms Brothers Body Shop in Columbus, from his personal collection. Many other individuals as well as institutions shared their postcards with me and are listed below. Those whose cards are included in the book are acknowledged in the text. Those individuals or institutions who shared their cards by telephone or in person are as follows: Carl Anderson, the Atlanta History Center, the Atlanta-Fulton County Public Library, Mary "Petey" Borders, Micki Cabaniss, David Clark, Teresa Cole, the Columbus Museum, Columbus State University, John Cunningham, Gary Doster, Jeffrey L. Durbin, Rusty Estes, Tom French, the Georgia Department of Archives and History, Steve Gurr, Walter Hale, Agatha Harden, Marsha Hatcher, Vickie Harville, Ed Levine, Jim Lewis, Joe McCannon, the Middle Georgia Archives in Macon, Edward W. Neal, Tony Perry, Mary Lewis Pierson, Nancy Reid, Betty Roberts, Mary Wade Robinson, Joe and Libba Russell, Pat Sabin, Janet Scroggins, John M. Sheftall, Frank Schnell, Mary Lee Schomburg, Ginger Smith, Jack Stroud, Susan Woodall Stuckey, the Troup County Archives (Kaye Minchew), the University of Georgia's Hargrett Library (Linda Aaron), and Mrs. Clarence Wilson.

INTRODUCTION

Columbus, Georgia, was founded in 1828—a planned city on Georgia's westernmost frontier. In this book I have selected and arranged postcards to present the city much like the early postcard distributors did.

This book is arranged as a tour of the city, beginning with cards that link to the Chattahoochee River. In Columbus, Broad Street/Broadway and the avenues are on a north-south axis, with the streets on an east-west axis. The book proceeds with each chapter representing a different section of town. In the last chapter, I have placed cards that did not fit elsewhere or reflected special events. While the primary scope of the book is from 1905 to 1942, I have sometimes jumped past the latter date to include a card or an event. I have also used the historic names of streets rather than reflecting any recent name changes. I have most often used Broad Street, as found on the earlier cards, rather than Broadway—its official name since about 1928.

Collecting postcards of my hometown, where some of my ancestors arrived in 1836, has long been a favorite hobby of mine. Postcards provide an insight into the past and can suggest many points of discussion. I used my collection many times to talk about early twentieth century Columbus with my grandmother, Helen Russell Brooks, before her death in 1993. It is interesting that the earliest Columbus scenes to appear on postcards coincided with the year and month of her birth, August 1905, so there were many scenes on postcards that she could not recall. Hopefully this book will help others start discussions with their relatives about Columbus in earlier years.

Postcards do not provide a comprehensive history of an area, and certainly those in this book do not attempt to either. One can only print what exists and what one can find. These cards provide a market-driven look at a city. Picture postcards were published and sold; they were rarely distributed free unless they were business advertisement cards. The Columbus postcards were not issued by a government agency or by the early Chamber of Commerce or Board of Trade, as far as we know. These cards for the most part show the city at its best—its beautiful tree-lined streets, community landmark buildings, picturesque parks, and in the case of locally generated real photo cards, some disasters. I have limited this book to picture postcards, some real photo postcards, and no family photo postcards. Columbus has an incredible wealth of photographs of the city and its people, many of which have appeared in other local books. Postcards represent a special look at a city, and that is the direction I chose to take in this book.

The publishing of view or picture postcards became a national phenomenon in the early twentieth century in the United States, and so it was when the craze hit Columbus in 1905. The social editor of the *Enquirer-Sun* on August 20, 1905, lamented the lack of any picture postals of Columbus. Ten days later, on August 30, we find the earliest postmarked view card in this book. While the photographs that were used could have been taken locally, most often a national postcard publisher would have had them made.

Frequently several different postcard companies used the same view over a number of years. Postcards were usually printed by a major national postcard company and then imprinted with the name of the local distributor who ordered the cards. Others were handled totally at the local level.

In Columbus the S.H. Kress Company, a national five-and-dime store chain, as well as several local businesses, distributed the first postcards that appeared between 1905 and 1908. Carl Schomburg, jewelers, and the W.A. White Company, a news and postcards business, had cards printed and they were listed on them as distributors. The White Company and many other distributors had cards printed in Germany, where the finest cards were published until World War I began in 1914. Another early local distributor was J.N. Pease and Company, book dealer and stationer. That company's role ended with the death of Mr. Pease in 1907. The Columbian Book Store, operated by Charles Pitchford, was another early distributor. Among these, only the White Company advertised in the city directories as early as 1908 that they sold postcards. They arranged for the printing and then sold postcards as late as the 1950s, if not later. Other local firms that later produced or issued cards include Nic Martiniere, Boyce Brothers, and the Columbus Office Supply Company.

There is no complete collection of Columbus postcards. A major collection of historical and archival material about the city and the region is currently housed in the Chattahoochee Valley Historical Collections in the Archives at the Columbus State University (formerly Columbus College) Library. There is a great need for more visibility for this collection, which we hope will be part of a new citywide archive proposed for a downtown location. Anyone with historical material about Columbus and the area (letters, photographs, journals, scrapbooks, etc.) should consider donating the material to the Columbus State University Collection for permanent retention. Hopefully, as other postcards surface, they can be donated there to start a local postcard collection.

Most of the postcards in this book are from my personal collection, with loans from the Historic Columbus Foundation where several major collections have been donated, and from Mike Helms, a private collector like myself. For those who are not postcard collectors, it is a whole world unto itself. There is a Georgia Postcard Club, which sponsors two large annual postcard shows for buying cards each year in Atlanta, national magazines, and, as with any other collectable, many types of collections and prices. Several cards used in this book were purchased off the Internet eBay auction site, a new way to expand your collection.

One of the discoveries made while preparing my collection for publication was the existence of an early local postcard enthusiast and collector, William F. Thomas (no relation). I have purchased at different shows some of the cards he mailed to other collectors. He swapped Columbus postcards as early as 1910 with people all over the United States, as did many others during the early heyday of postcard collecting, and he started the Chattahoochee Valley Collectors' Club. I began the book with a postcard sent in 1914 by Thomas on behalf of the club to recruit members. Hopefully this book will fulfill Thomas's interest in sharing his enthusiasm, as well as mine, for collecting postcards.

——Kenneth H. Thomas Jr.
 May 2001

All cards belong to the author unless noted otherwise.

One
ALONG THE RIVER

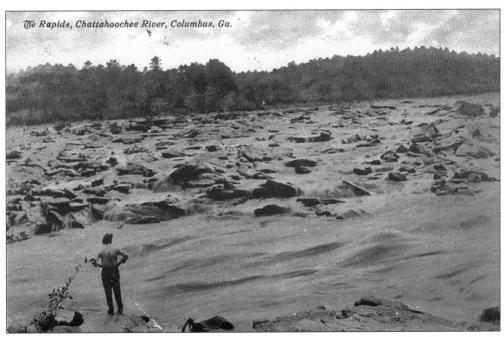

CHATTAHOOCHEE RAPIDS. William F. Thomas of Columbus, early postcard collector for the Chattahoochee Valley Collectors' Club, sent this card in 1914. In the printed message on the back, he was recruiting members who would also receive the magazine, *The Chattahoochee Explorer.*

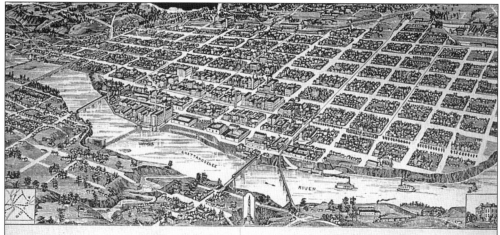

"THE LOWELL OF THE SOUTH"
(COLUMBUS, GEORGIA) Population, City and Suburbs, 40,000

14 Cotton and Woolen Mills; 2 large Clothing Manufacturing Establishments; 3 Cotton Compresses; 3 Cotton-seed Oil Mills; 4 Iron Foundries; 4 Ice Factories; 4 Hosiery Mills; 1 very extensive Wagon Factory; 1 Buggy Factory; 3 Candy Factories and Syrup Refineries; 7 very large Brick Plants; and numerous other minor industries incident to a manufacturing centre. Total weekly pay roll of these industries is between $60,000 and $75,000. Total number of employees, 10 000.

YOUNG ADVERTISING SERVICE---Bill Posters.

THE LOWELL OF THE SOUTH. This was one of the nicknames given the city and reproduced above is the bird's-eye view or panoramic map published in 1886 by Wellge. The population of 40,000 and other statistics indicate Young Advertising Service of Columbus published this card around 1908 to 1910. (Courtesy of the Historic Columbus Foundation, Dexter Jordan Collection.)

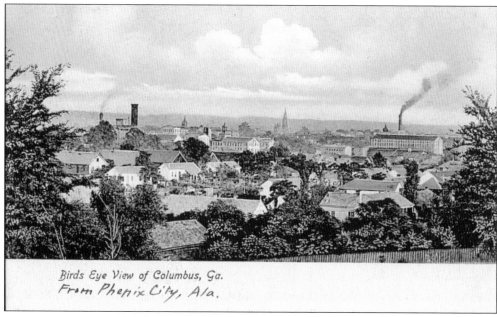

BIRD'S-EYE VIEW OF COLUMBUS, GEORGIA, FROM PHENIX CITY, ALABAMA. This c. 1905 view was made from the Alabama side of the river and looks southeast with the Broad Street standpipe in the left background, the First Presbyterian Church steeple in the center, and the Eagle and Phenix Mills smokestack to the right. Rooftops in the foreground are on the Alabama side.

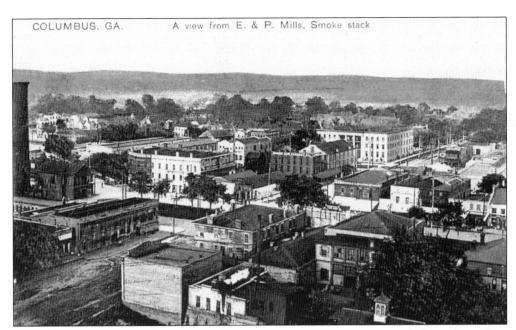

A View from the Eagle and Phenix Mills Smokestack. This *c.* 1908 view looks northeast from near the river and shows the city with the Broad Street standpipe at the left (at Broad and Thirteenth Streets), the Racine Hotel in the right rear (at First Avenue and Thirteenth Street), and other buildings from the 1200 block of Broad Street in the foreground. (Courtesy of Historic Columbus Foundation, Walter Wyatt Collection.)

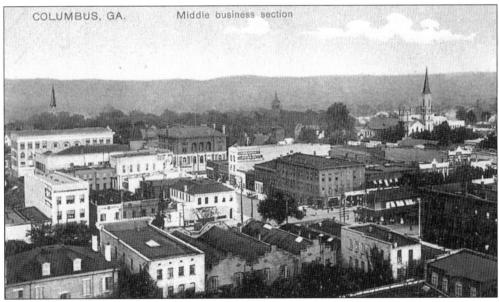

A View of the Middle Business District. This *c.* 1908 view is a companion to the postcard above. This view looks east and southeast also from the mills smokestack. The Masonic Lodge (later the Flowers Building) is in the left rear, at First Avenue and Twelfth Street, the Post Office across the intersection, and the First Presbyterian Church further south on First Avenue. The buildings in the foreground are on Front Avenue.

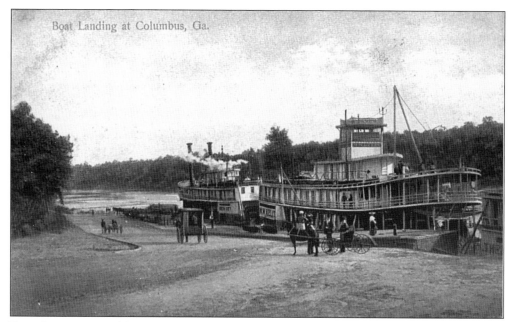

BOAT LANDING WITH TWO RIVERBOATS. The city wharf still survives below the Columbus Iron Works on the Chattahoochee River. This *c.* 1908 view shows the *Queen City* and the *M.W. Kelly* at the wharf. The *M.W. Kelly* sank that year at this wharf.

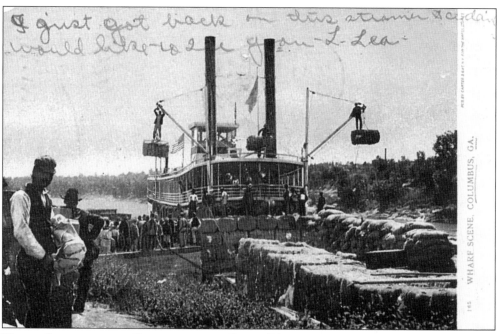

WHARF SCENE ON THE CHATTAHOOCHEE RIVER. This 1905 view shows an unidentified boat unloading bales of cotton, the raw material for the mills. Carter and Gut of New York published this postcard for S.H. Kress Company, a postcard distributor. It is postmarked August 30, 1905, the earliest postmark for a Columbus view card known and is the first series published for the city. (Courtesy of Mike Helms.)

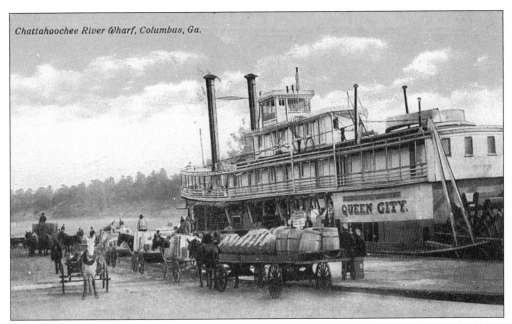

Chattahoochee River Wharf, Columbus, Ga.

THE *QUEEN CITY* AT THE COLUMBUS WHARF. The *Queen City* was one of the most photographed boats on the river and was featured in many postcards, such as this 1913 view. Note the two lifeboats atop the rear. The boat was built in 1891 in Columbus and was later dismantled at the Columbus Wharf.

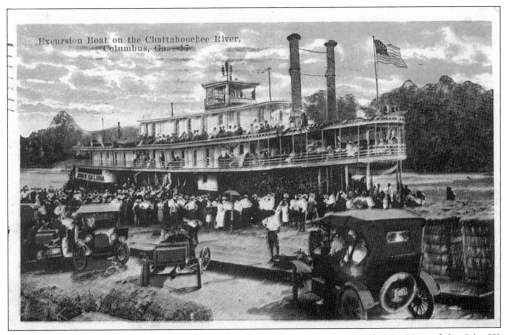

Excursion Boat on the Chattahoochee River, Columbus, Ga.

EXCURSION BOAT ON THE CHATTAHOOCHEE RIVER. This is a view mailed in 1924 of the *John W. Callahan* taking on passengers for an excursion trip, one of the many activities for the riverboats of the era. This boat sank on March 25, 1923 in Florida. (Courtesy of Historic Columbus Foundation, Dexter Jordan Collection.)

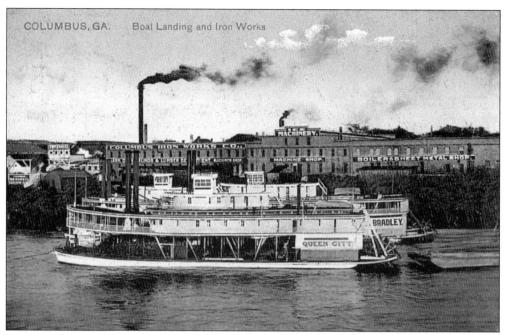

COLUMBUS, GA. Boat Landing and Iron Works

BOAT LANDING AND COLUMBUS IRON WORKS. This 1909 postcard presents a great view of the Columbus Iron Works from the river with the *Queen City*, *W.C. Bradley*, and at least one other unidentified boat at the wharf. The railroad bridge is immediately to the left. Opened in 1853, the building is now the Columbus Iron Works Convention and Trade Center.

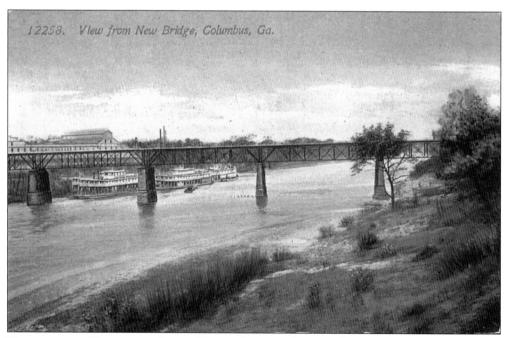

12258. View from New Bridge, Columbus, Ga.

VIEW FROM THE DILLINGHAM STREET BRIDGE LOOKING SOUTH. The Iron Works and the riverboats are seen in this 1912 view from the newly completed Dillingham Street Bridge. (Courtesy of the Historic Columbus Foundation, Dexter Jordan Collection.)

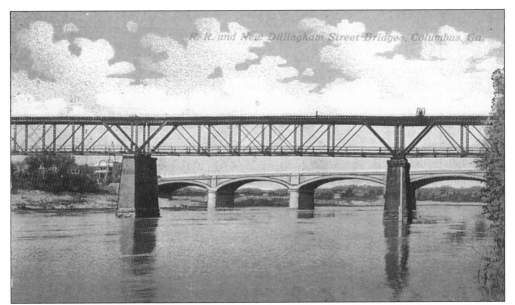

RAILROAD AND NEW DILLINGHAM STREET BRIDGES. This 1914 view looks north up the Chattahoochee with the railroad bridge in the foreground and the new Dillingham Street Bridge in the rear. Some buildings from Girard, Alabama, can be seen on the west end of the Dillingham Street Bridge. At the Alabama end, the bridge later had the sign, "Leave Alabama and Enter Georgia" because Georgia owns the entire Chattahoochee River. (Courtesy of Mike Helms.)

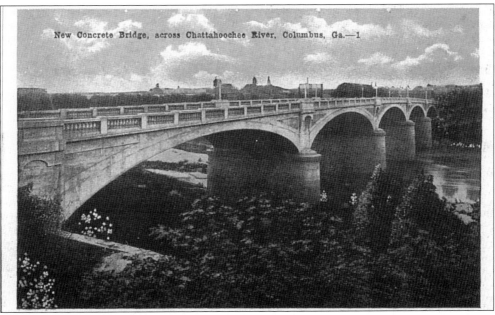

DILLINGHAM STREET BRIDGE. The Hardaway Contracting Company, a local firm, completed the bridge in 1912; it replaced a covered bridge built by Horace King, a former slave. Another postcard indicates that Columbus was located on the Dixie Overland Highway, the Franklin D. Roosevelt Highway going to the Gulf, and the Taft Memorial Highway leading to Fort Myers, Florida—all designations long forgotten.

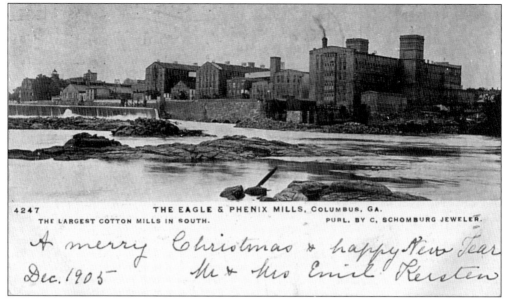

4247 THE EAGLE & PHENIX MILLS, COLUMBUS, GA.

THE LARGEST COTTON MILLS IN SOUTH. PUBL. BY C, SCHOMBURG JEWELER.

A merry Christmas & happy New Year
Dec. 1905 *Mr & Mrs Emil Kersten*

THE EAGLE AND PHENIX MILLS—LARGEST COTTON MILLS IN THE SOUTH. The mills, rebuilt after the Civil War, were for many decades the lifeblood of Columbus. The dam and the waterfalls on the left provided the power. This card is part of one of the earliest series published in 1905, the first year of Columbus view cards. It was distributed by C. Schomburg Jewelers, a firm still in business, and sent by Emil Kersten and his wife as a Christmas card in December 1905.

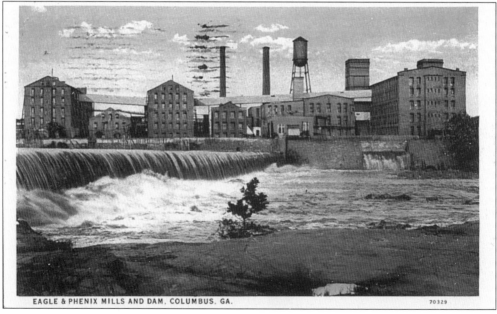

EAGLE & PHENIX MILLS AND DAM, COLUMBUS, GA. 70329

EAGLE AND PHENIX MILLS AND DAM. This *c.* 1927 view of the mill shows the connecting upper level-covered walkway between the buildings. Located along the river between Twelfth and Thirteenth Streets, much of the mill survives today. The mill village for this factory was across the river in Alabama, accessible over the Fourteenth Street Bridge. The community had several names but eventually became Phenix City, named after the mill.

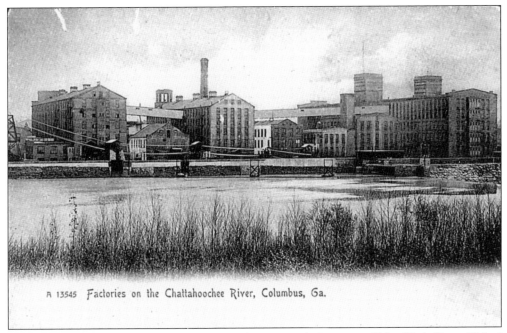

A 13545 Factories on the Chattahoochee River, Columbus, Ga.

FACTORIES ON THE CHATTAHOOCHEE RIVER. The Rotograph Company of New York City published this more picturesque view of the Eagle and Phenix Mills in 1905. The mills have been owned by Fieldcrest Mills since 1978. (Courtesy of Historic Columbus Foundation, Dexter Jordan Collection.)

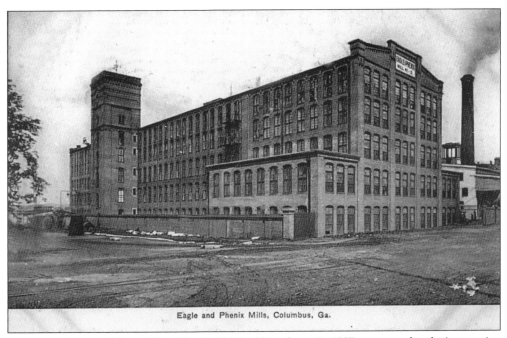

Eagle and Phenix Mills, Columbus, Ga.

EAGLE AND PHENIX MILLS, MILL NO. 3. This building shown in 1907 was erected at the intersection of Front Avenue and Twelfth Street and still survives as part of Fieldcrest Mills. The Chattahoochee River Club is to the left of this view at 1100 Bay Avenue.

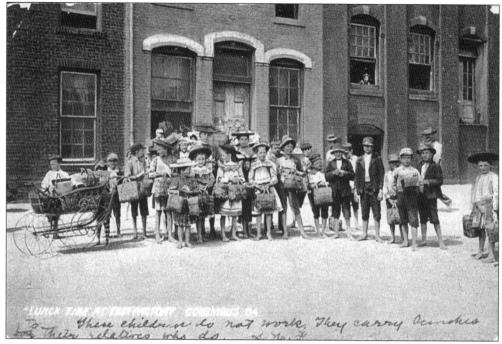

LUNCH TIME AT THE FACTORY. The message for this 1907 view reads, "These children do not work. They carry lunches to their relatives who do." Special provisions were made to allow the children to do this.

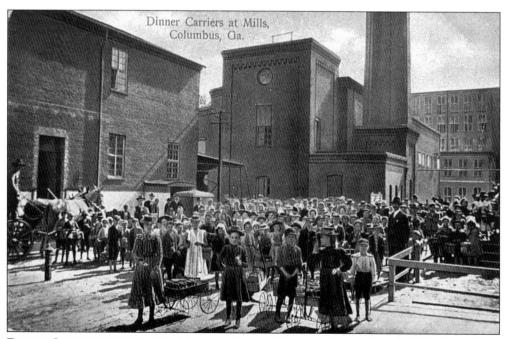

DINNER CARRIERS AT THE MILLS. A large number of children carrying lunch to their relatives are seen in this *c.* 1909 postcard. Note the various wagons and even baby carriages used for transport in this postcard and the one above.

18

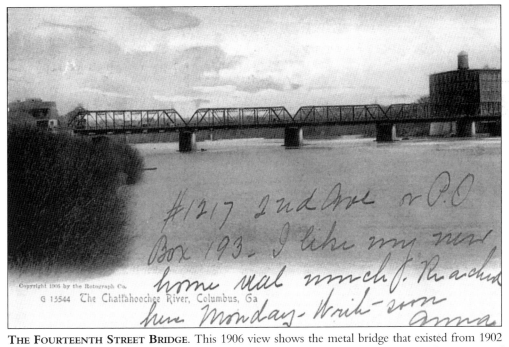

G 15544 The Chattahoochee River, Columbus, Ga

#1217 2nd Ave or P.O Box 193. I like my new home real much. Reached here Monday. Write soon Anna

THE FOURTEENTH STREET BRIDGE. This 1906 view shows the metal bridge that existed from 1902 until 1922. The Muscogee Manufacturing Company is at the right end of the bridge. The portions of this mill north of Fourteenth Street were demolished in 1997 for the Total Systems Campus.

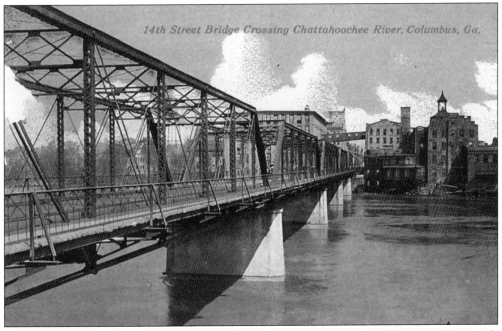

14th Street Bridge Crossing Chattahoochee River, Columbus, Ga.

THE FOURTEENTH STREET BRIDGE AND THE MUSCOGEE MANUFACTURING COMPANY. The cupola of the mill can be seen on the right in this *c.* 1914 view. This building is now part of Fieldcrest Mills. (Courtesy of Historic Columbus Foundation, Dexter Jordan Collection.)

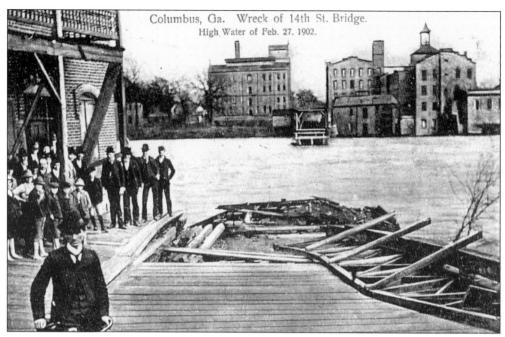

Columbus, Ga. Wreck of 14th St. Bridge.
High Water of Feb. 27. 1902.

THE WRECK OF THE FOURTEENTH STREET BRIDGE. This *c.* 1908 card is based on a photograph that predates the postcard era—a photograph illustrating the destruction by high water of the wooden-covered bridge on February 27, 1902. The Mott House, used as the mill office, is to the left of the mill. The bridge was replaced with the metal one shown on the previous page and below. (Courtesy of Gary Doster.)

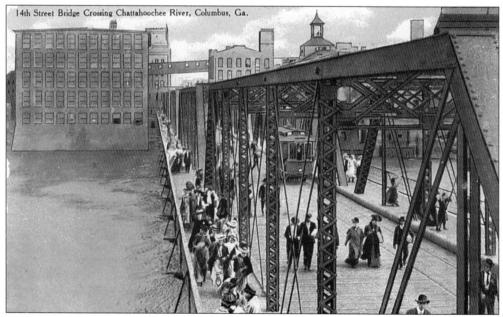

14th Street Bridge Crossing Chattahoochee River, Columbus, Ga.

THE FOURTEENTH STREET BRIDGE. This *c.* 1910 view shows pedestrian use both on the outside of the bridge as well as inside on the street. The trolley line also ran across the bridge to the Alabama side. (Courtesy of Historic Columbus Foundation, Walter Wyatt Collection.)

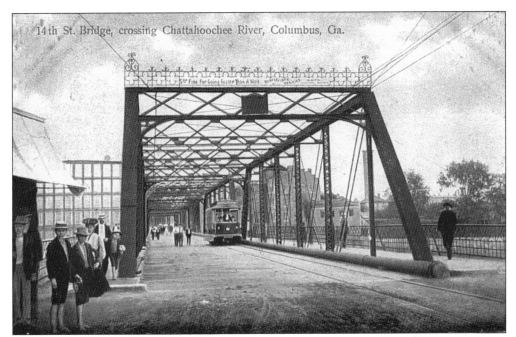

THE ALABAMA SIDE OF THE FOURTEENTH STREET BRIDGE. The pedestrian sidewalks on either side of the metal bridge are easier seen in this *c.* 1907 view. The metal sign on top of the bridge reads, "$5 fine for going faster than a walk. Pedestrians and vehicles." There is also a pipeline on the right.

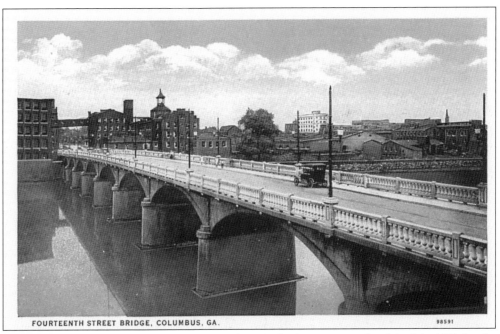

FOURTEENTH STREET BRIDGE, COLUMBUS, GA.

98591

THE NEW FOURTEENTH STREET BRIDGE. The new bridge was completed in July 1922 by the Hardaway Company. It survives today, although now a pedestrian bridge and renamed for Horace King, the former slave who built many bridges and buildings in the area. A new Thirteenth Street Bridge opened one block south in 2000, providing access across the river where previously there was no bridge.

21

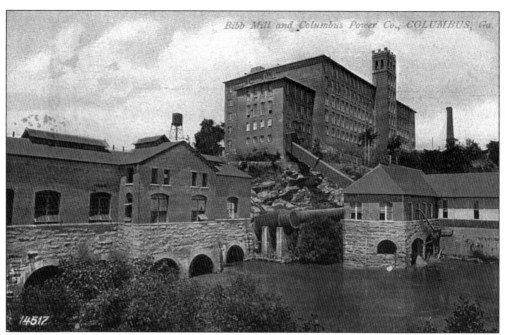

BIBB MILL AND COLUMBUS POWER COMPANY. This mill, shown *c.* 1906, was built *c.* 1902 several miles north of the Eagle and Phenix and Muscogee Mills. The Highlands Dam was the power source and is adjacent to the power plant in the left foreground. This mill was expanded and still stands in Bibb City at Thirty-eighth Street.

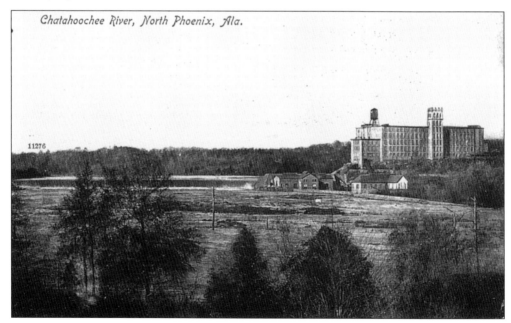

THE BIBB MILL AND COLUMBUS POWER CO. FROM THE ALABAMA SIDE. This 1910 view shows that while the Georgia side of the river was industrialized, no parallel activity happened on the Alabama side. Since no bridge was ever built at this location, there was no link to Alabama. Bibb City, the mill village for the Bibb Mill, was built around this mill and northwards and survives today.

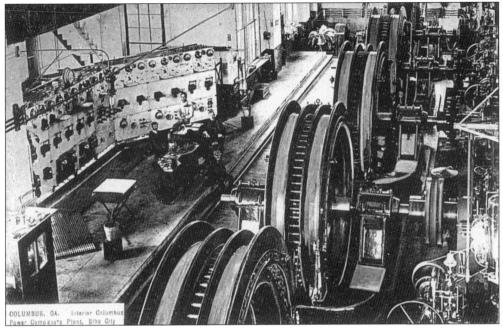

INTERIOR OF THE COLUMBUS POWER COMPANY'S PLANT, BIBB CITY. This postcard shows a 1907 view inside the power company building, which adjoined the dam and harnessed the river's power. (Courtesy of Historic Columbus Foundation, Dexter Jordan Collection.)

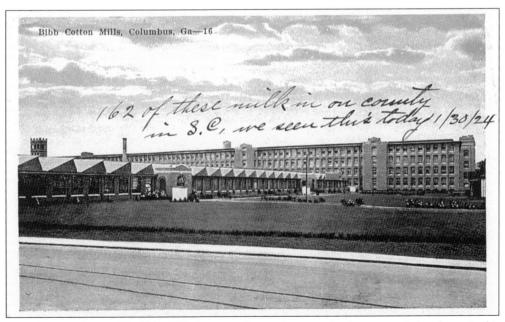

BIBB COTTON MILLS. The Bibb Mill shown on the previous page has been expanded as shown in this 1924 view and looks much like this today. The far right entrance is at First Avenue and Thirty-eighth Street and has "Bibb Manufacturing Co. 1920" at the top. The crenellated tower at the far left is part of the original building. The building on the left is the weave shed.

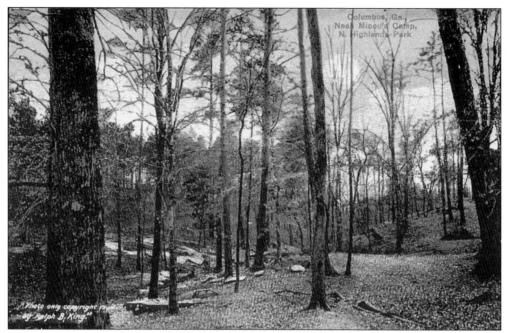

NORTH HIGHLANDS PARK. This popular park, began in the 1890s near the Highlands (or North Highlands) Dam between Fortieth and Forty-fifth Streets, was replaced in 1919 by Bibb City's second housing development. The view "Near Micco's Camp" is by local photographer Ralph S. King. Printed in Germany, the card was sold by White's on Twelfth Street. All four of these views are *c.* 1908.

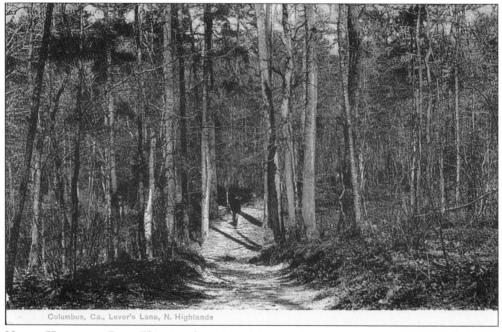

NORTH HIGHLANDS PARK. This view shows Lover's Lane, a picturesque spot. With the second phase of Bibb City in 1919, developer Earle Draper adapted the plan to the terrain, preserving the earlier beauty. This card was also printed in Germany for White's.

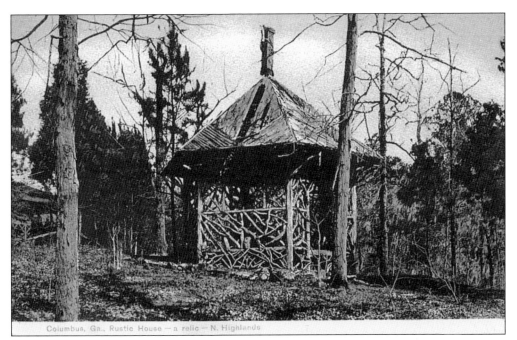

Columbus, Ga., Rustic House — a relic — N. Highlands

NORTH HIGHLANDS PARK. Here the caption reads, "Rustic House-a relic." As with many popular postcard views, this and the other views of this park were reprinted often in different colors.

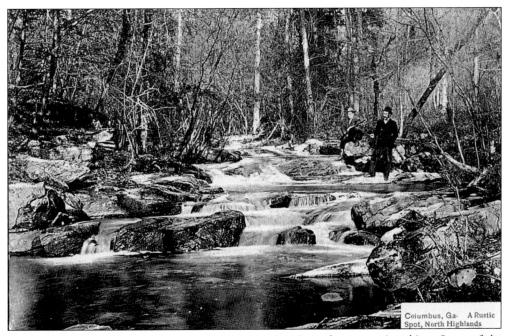

Columbus, Ga. A Rustic Spot, North Highlands

NORTH HIGHLANDS PARK. Here we see "A Rustic Spot," another romantic subject. Some of the terrain of this park can still be seen today in the midst of Bibb City and along the river. This *c.* 1908 card was published at the same time, and as part of the same set, as the one of Clapp's Factory on the following page.

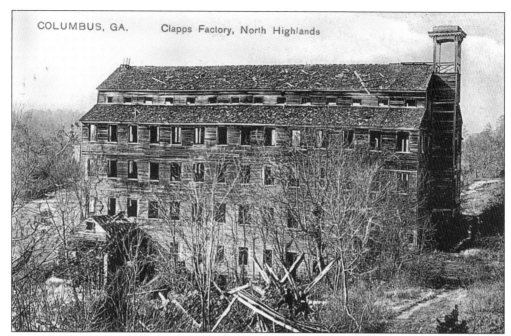

CLAPP'S FACTORY, NORTH HIGHLANDS. This factory began in 1837 and was rebuilt after the Civil War in 1866. It was named after one of its owners, J.R. Clapp, and closed in 1885. There was a mill community nearby and a cemetery. The mill burned March 19, 1910, and many postcards like this *c.* 1908 one survive—attesting to its popularity. (Courtesy of Mike Helms.)

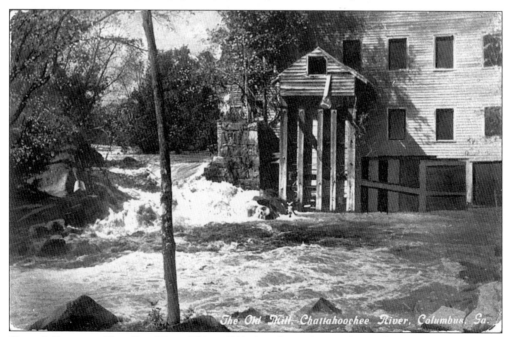

The Old Mill, Chattahoochee River, Columbus, Ga.

CLAPP'S FACTORY, THE OLD MILL. This *c.* 1910 view shows the wooden mill and the Chattahoochee River's proximity at this point. Clapp's Factory was located just south of where Roaring Branch Creek enters the Chattahoochee River, which is now the location of Oliver Dam begun in 1957.

Two

BROAD STREET/
BROADWAY

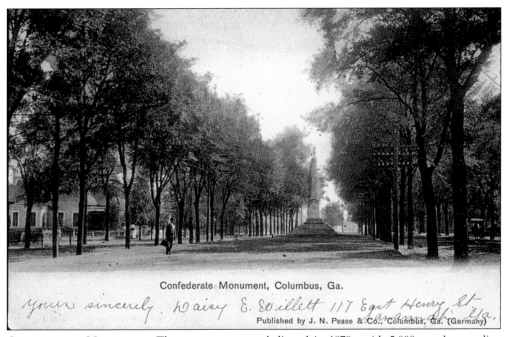

Confederate Monument, Columbus, Ga.

Published by J. N. Pease & Co., Columbus, Ga. (Germany)

CONFEDERATE MONUMENT. The monument was dedicated in 1879—with 5,000 people attending the laying of the cornerstone on April 14—and is located in the median of Lower Broad Street, between Seventh and Eighth Streets. Honoring Confederate soldiers, it remains at this location today. This *c.* 1906 postcard was distributed by J.N. Pease & Co., a local book dealer; Pease died in 1907.

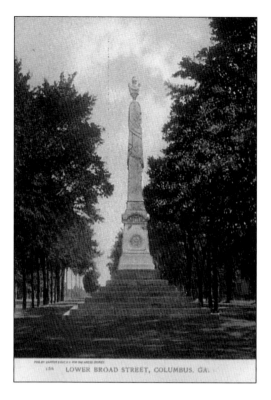

LOWER BROAD STREET, COLUMBUS, GA.

CONFEDERATE MONUMENT ON LOWER BROAD. The seal of the Confederacy is on the north face of the monument. Carter and Gut of New York published this *c.* 1905 card for the Kress Stores. This series contains the earliest postmarks for Columbus postcards and was issued in 1905; the first year view cards were made for Columbus.

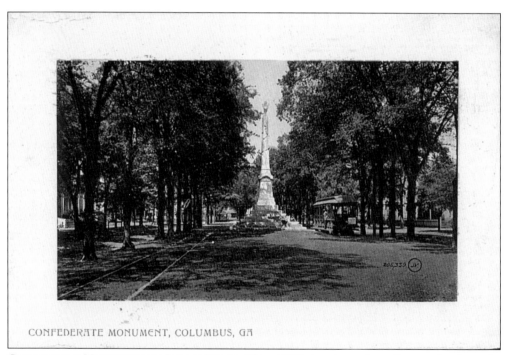

CONFEDERATE MONUMENT, COLUMBUS, GA

CONFEDERATE MONUMENT ON LOWER BROAD. This *c.* 1910 view shows the trolley running down the tracks in the median of Broad Street. Note the tracks on either side of the monument.

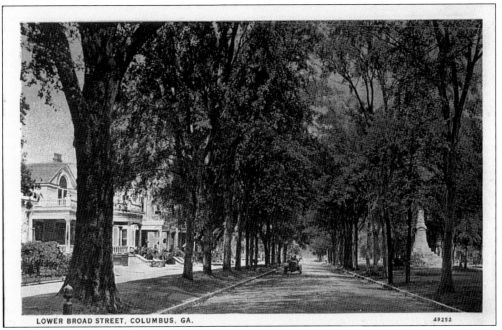

LOWER BROAD STREET, COLUMBUS, GA. 49252

LOWER BROAD STREET. This *c.* 1927 view of the same area shows some of the houses on the west side of Broad Street, in the 700 block. Many of these houses remain today in the Columbus Historic District. The Historic Columbus Foundation Headquarters at 700 Broad is nearby, on the right side of the monument in this view.

On Broad Street, COLUMBUS, GA.

BROAD AT NINTH STREET. The Broad Street Passenger Station is shown in the left rear. This *c.* 1911 view is of the east side of Broad, between Eighth and Ninth Streets. Several of these houses remain today in the 800 block.

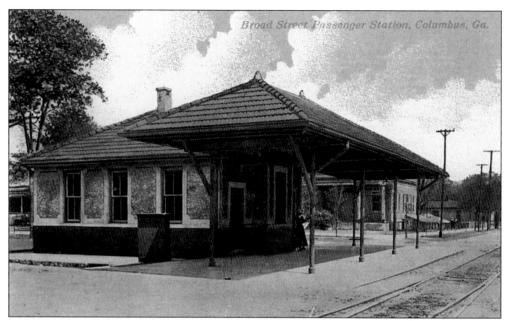

BROAD STREET PASSENGER STATION. This Central of Georgia Railroad Station stood in the middle of Broad Street at Ninth Street, with the railroad bridge crossing the river at Ninth Street. This is a *c.* 1914 view looking northeast as the station faced the tracks on Ninth Street. It was later used as an army recruiting station and a Howard Bus Station. It has been demolished.

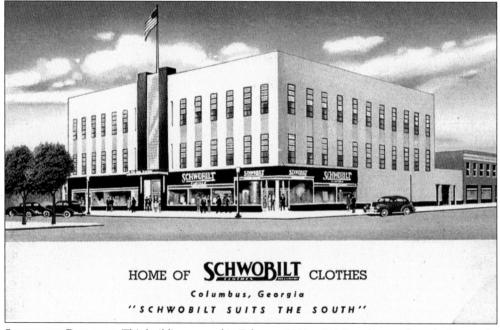

SCHWOBILT BUILDING. This building opened in February 1941 at 945 Broadway and was built over the Webster Building, at the southwest corner of Broad and Tenth Streets. The building served for many years as the headquarters and manufacturing place for Schwobilt Clothes, owned by the Schwob family. In the 1990s it was transformed into the Hardaway Company headquarters.

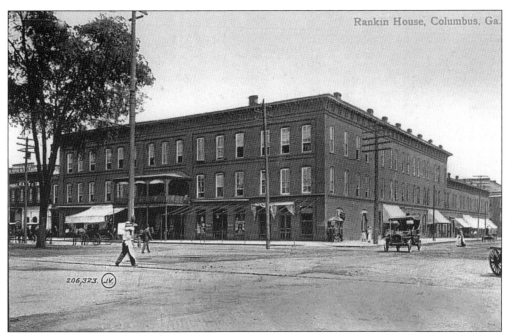

RANKIN HOUSE. The hotel was rebuilt in 1880 and located at 1004 Broad Street, at the northeast corner of Broad and Tenth Streets. This card has the following on the back, "Reuben H. England built this house in the year [1880]. I like to have lost my life in the building that was burned down on the same ground before Dad built this one . . . 10/31/1911 J.R.E."

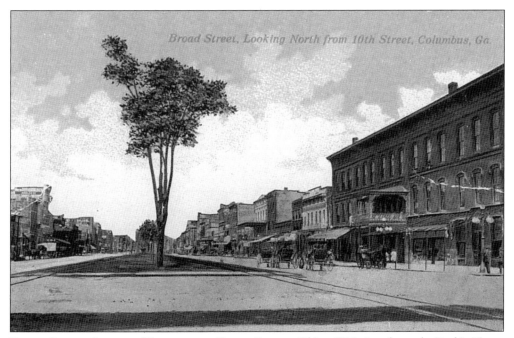

BROAD STREET, LOOKING NORTH FROM TENTH STREET. This *c.* 1913 view shows the Rankin House hotel on the right. It remained open as a hotel for 92 years until October 1972. It is now used by Columbus State University's Music Department.

31

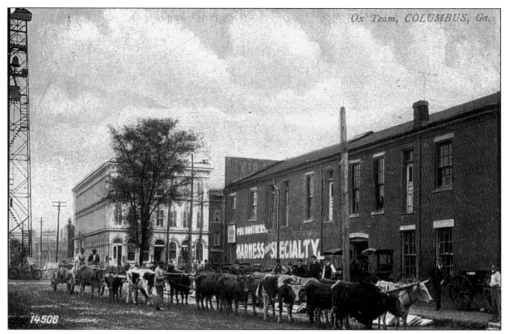

Ox Team at Broad and Eleventh Streets. Looking east on Eleventh Street toward the Iron Bank, the Bell Tower is on the left and the Pou Brothers Harness and Specialty Business is on the right. Sears and Boland's 16-ox team is stopped for supplies while transferring their sawmill camp from Georgia to Alabama. The photograph was taken by Constantine de George in 1904 and the postcard printed in 1907.

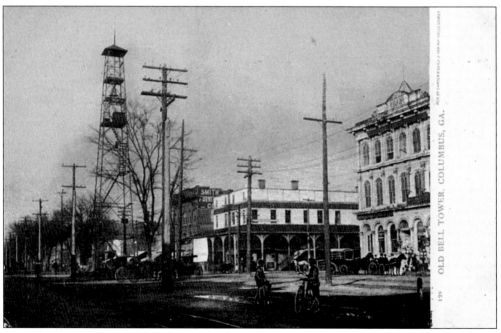

Bell Tower at Broad and Eleventh Street. One sees the Bell Tower in the middle of the Broad and Eleventh Streets intersection looking northeast in this 1905 card. The photograph used here appears to predate the 1902 construction of the Needham Building shown in the views on page 36.

THE BELL TOWER. This tower was in the middle of the intersection of Broad and Eleventh Streets from at least the 1880s until 1906. The bell alerted people to fires and called out the volunteer firemen. In 1906 advances in fire safety eliminated the need for this tower, which was sold at public auction that year. Charles F. Pekor Jr. mailed this card, which was distributed by Schomburg's, in May 1906 while he was at Auburn, Alabama. (Courtesy of Mike Helms.)

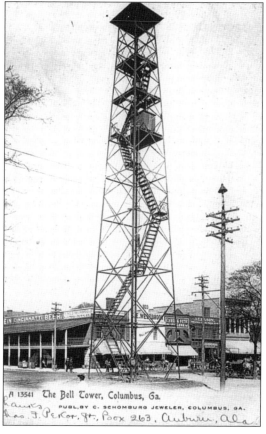

A 13541 The Bell Tower, Columbus, Ga.
PUBL. BY C. SCHOMBURG JEWELER, COLUMBUS, GA.

BROAD STREET NORTH FROM ELEVENTH STREET. This *c.* 1905 view is from the Bell Tower; in the distance is the standpipe at Fire Station No. 1 in the middle of Broad, north of Thirteenth Street. The bell was removed by 1906 to a fire station; it was located there until 1952, when it was given by the city to St. Paul Methodist Church for the new church on Wildwood Avenue. The bell remains there today. (Courtesy of Mike Helms.)

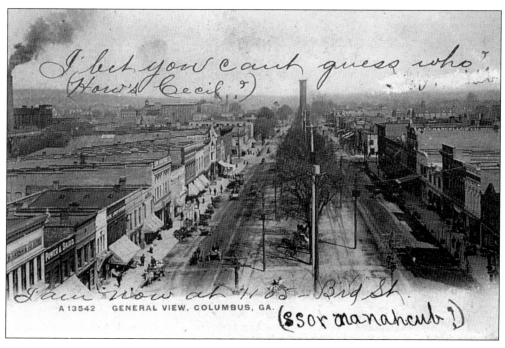

A 13542 GENERAL VIEW, COLUMBUS, GA.

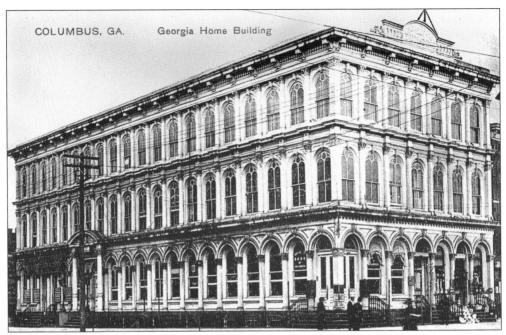

GEORGIA HOME BUILDING. The building in this *c.* 1908 view is often called the Iron Bank, or First National Bank. It is located at 1046 Broad Street at the southeast corner with Eleventh Street. A rendering of this prefabricated iron building appeared on a 50¢ paper bill issued by the Bank of Columbus in 1862. The Georgia Home Insurance Company also owned it, hence its name on this card.

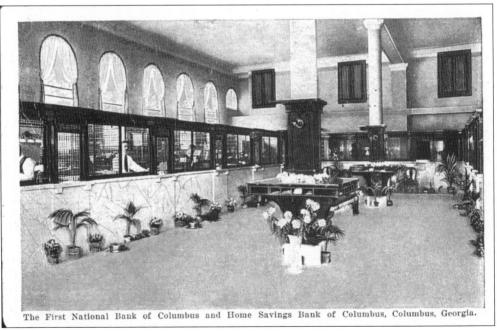

The First National Bank of Columbus and Home Savings Bank of Columbus, Columbus, Georgia.

INTERIOR OF THE FIRST NATIONAL BANK. This is a *c.* 1922 interior view of the above bank when it was operating as the First National Bank of Columbus. It is now used as architects' offices. Martiniere of Columbus published this card. (Courtesy of Gary Doster.)

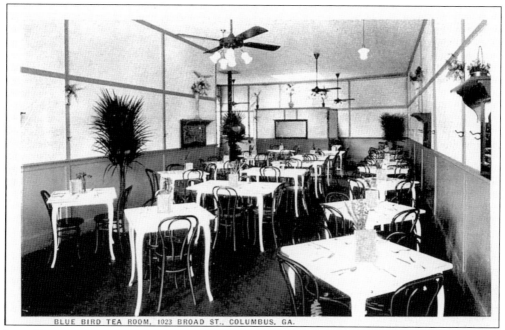

BLUE BIRD TEA ROOM. This *c.* 1927 view shows this establishment that was projected to be at 1023 Broad Street, in the block northwest of the Rankin House hotel. It is not proven that it ever operated at that location. The 1927 City Directory lists a place of the same name at 18 Twelfth Street within a drugstore. Martiniere of Columbus published this view. (Courtesy of Gary Doster.)

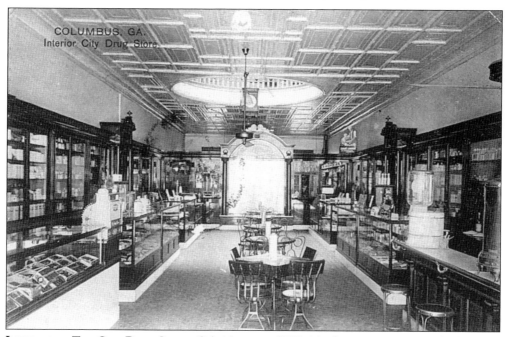

INTERIOR OF THE CITY DRUG STORE. C.A. Morgan and W.L. Meadows, proprietors, ran this business. This 1910 view shows the drugstore at 1142 Broad Street, its location for a number of years. (Courtesy of Gary Doster.)

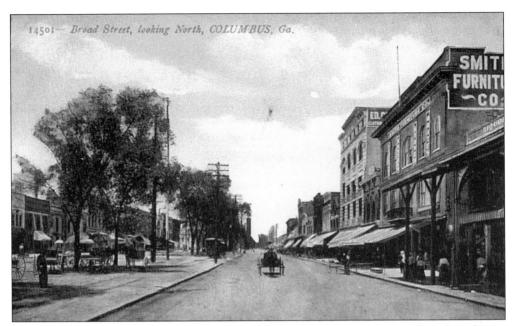

BROAD STREET AT ELEVENTH STREET, LOOKING NORTH. This view and the next three show the east side of this intersection during various decades. In this *c.* 1907 view, the large building third from the right is the Needham Building, built in 1902. Designed by T.W. Smith, it was called an ornament on Broad. It was where Ed Cohn Clothiers operated at 1114 Broad.

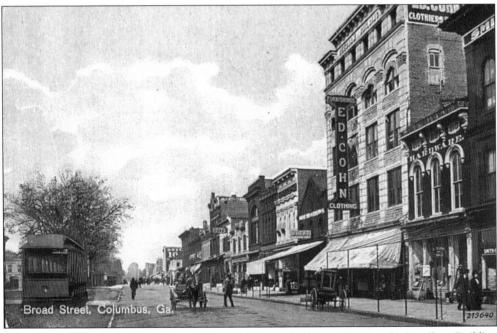

BROAD STREET AT ELEVENTH STREET, LOOKING NORTH. In this *c.* 1911 view, the Needham Building can be seen in its full four-story size, now with a marquee. Note the trolley at the left. The Needham Building survived until 1961 and was replaced by Walgreens.

36

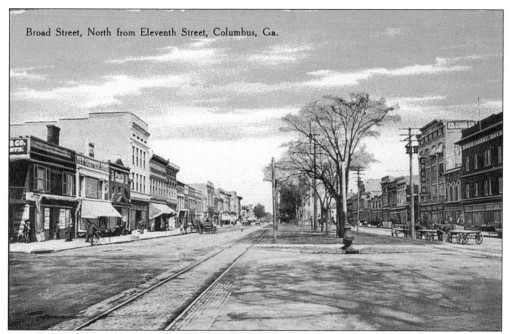

Broad Street, North from Eleventh Street, Columbus, Ga.

BROAD STREET AT ELEVENTH STREET, LOOKING NORTH. This *c.* 1912 view shows more of the businesses on the west side of the street. Note the water trough for horses in the center median.

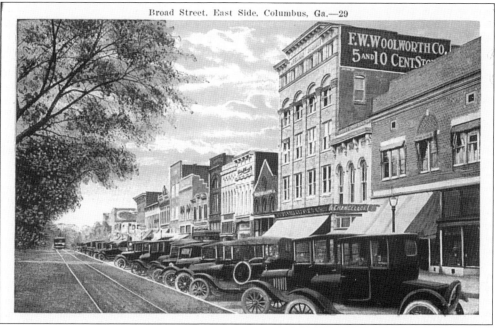

Broad Street, East Side, Columbus, Ga.—29

BROAD STREET AT ELEVENTH STREET, LOOKING NORTH. This *c.* 1928 view shows how automobiles changed the look of Broad Street and created a need for parking. Note the trolley line is still there and the Needham Building now has a Woolworth's sign because they were then located there. Chancellor's Men's Store is next door, near where it is located today at 1108 Broad. (Courtesy of Mike Helms.)

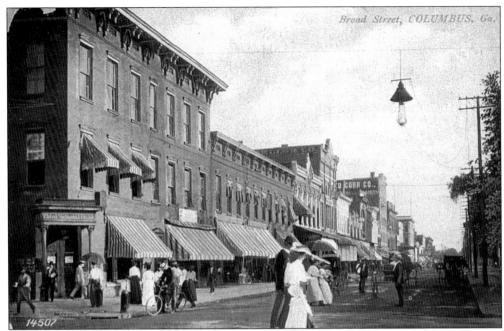

BROAD STREET AT TWELFTH STREET, LOOKING SOUTHEAST. The intersection shown here *c.* 1907 was a popular postcard selection for decades because of the trolley transfer station. The large building at the left was the Third National Bank, later Columbus Bank and Trust Company with a new front. This view of the east side of Broad at Twelfth Streets shows the same block as on the previous pages of Eleventh Street looking north. Note the early streetlight.

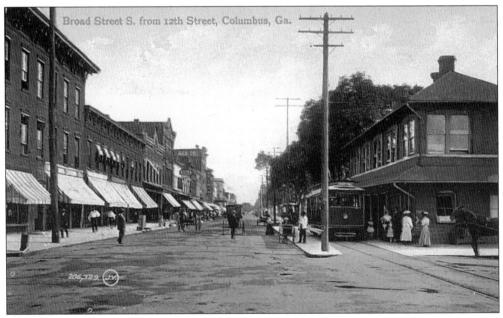

BROAD STREET AT TWELFTH STREET, LOOKING SOUTH. Here *c.* 1912 one sees a trolley at the transfer station where people transferred from one trolley to another. There are many horse-drawn vehicles visible. Many people watched parades from the second floor of the transfer station.

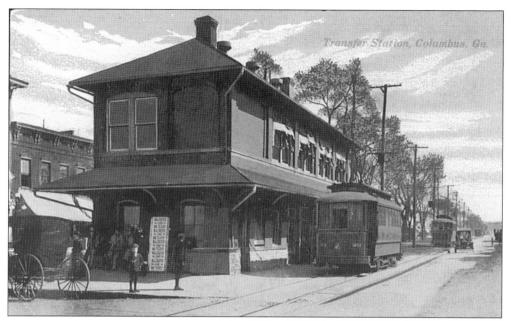

TRANSFER STATION. This *c.* 1912 view shows the transfer station in greater detail. The second floor was the office of John F. Flournoy, who ran the Columbus Railroad Company which operated the trolley system. He also developed Wildwood Park. Built in 1895, the station was torn down in 1941 and replaced with a newer building, which is also gone.

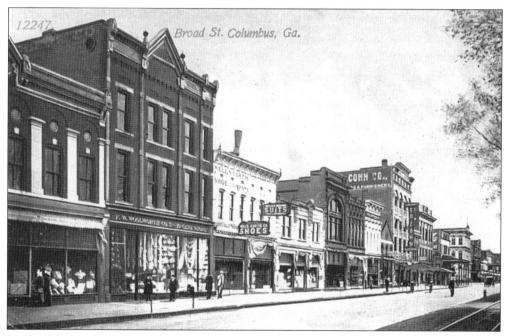

BROAD STREET, EAST SIDE BETWEEN TWELFTH AND ELEVENTH STREETS. In this *c.* 1918 view the second storefront on the left is the F.W. Woolworth Building at 1132-1134 Broad. To the right of it is the Wells-Curtis Shoe Company at number 1130. Note the boot on the roof. Kirven's is to the left of Woolworth's at number 1136. (Courtesy of Mike Helms.)

BROAD STREET AT TWELFTH STREET, LOOKING SOUTH. Automobiles are parked along the median in this *c.* 1929 postcard. On the right (west) side is the Kress building at 1117; it survives today as a shell due to a fire. It operated there from around 1918 until 1979. The Grand Theater was also in this block.

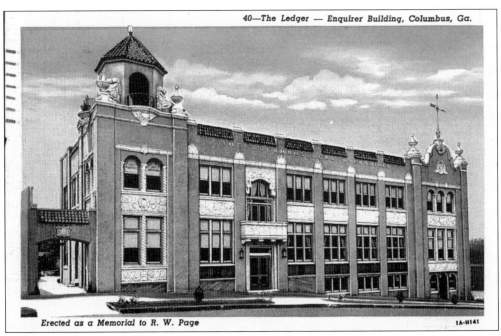

THE *LEDGER-ENQUIRER* BUILDING. It was built in 1931 as a memorial to R.W. Page, the owner of the *Ledger* newspaper who died in 1920, and is located at 17 West Twelfth Street, a block west of the transfer station. Still the offices of the newspaper, it was enlarged in 1971 and in 1989, and has replaced several businesses at the corner of Broad and Twelfth Streets. The architects for the original building were Smith and Biggers of Columbus.

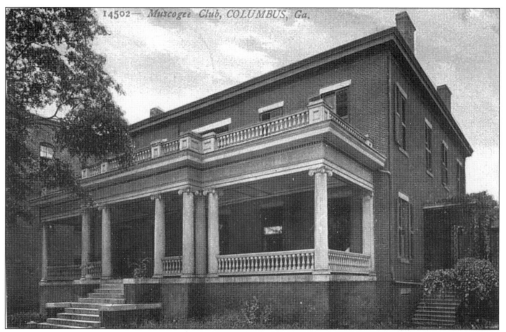

THE MUSCOGEE CLUB. This *c*. 1907 view is of the men's club that was converted from a former home at 1217-1219 Broad Street, on the west side of Broad just north of Twelfth Street. The club stayed at this location from about 1904 until the 1940s. By 1942 the Standard Club was at this address and by 1963, the Chickasaw Club. The building was later demolished.

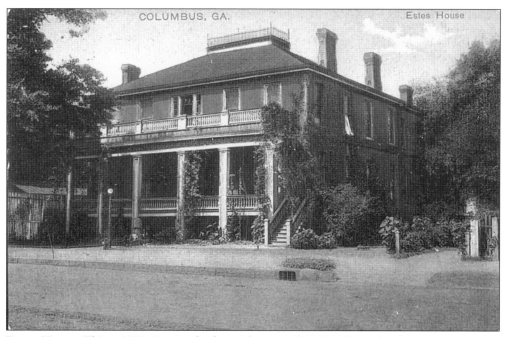

ESTES HOUSE. This *c*. 1908 view is of a former home at 1229 Broad, north of the Muscogee Club (above) that was converted to a small hotel or boarding house around 1904 by Dr. Charles Estes and family. By 1942 this site was Rothschild Furniture Company in a new building.

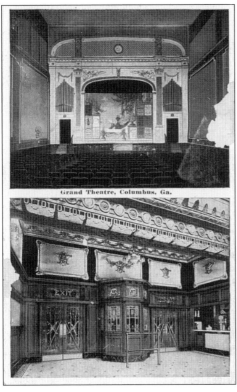

THE GRAND THEATER. This theater view (seen *c.* 1915) was ordered by S.D. Zacharias of Atlanta. On December 23, 1928, the *Ledger* announced, "Talking Movies Come to Columbus at this theater." The first talkie was "Street Angel" starring Janet Gaynor, who won Best Actress for her role. By 1942, Woolworth's had replaced the theater at 1131 Broad. (Courtesy of Mike Helms.)

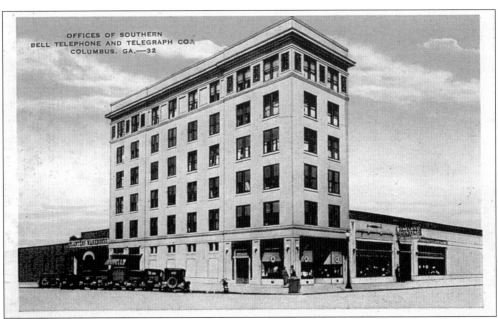

SWIFT-KYLE BUILDING. The Southern Bell Telephone and Telegraph Company and other offices were housed in this building at the time of this 1920s postcard. It was built in 1921–1922 by architects Hickman and Martin of Columbus at the northwest corner of Broad and Thirteenth Streets. A dealership to the right is selling Oakland and Pontiac cars. The building was torn down in 1989.

FIRE STATION NO. 1 AND STANDPIPE. This fire station was in the middle of Broad Street just north of Thirteenth Street until the 1920s when a new one was built just to the right (east) at Warren Street and this one torn down. The standpipe was moved to Wynn's Hill. The building to the left was the Broad Street Methodist Church from 1873 until 1912 when the congregation moved and formed the new St. Mark Methodist Church.

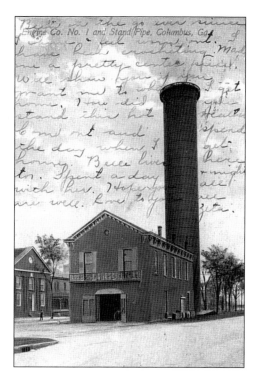

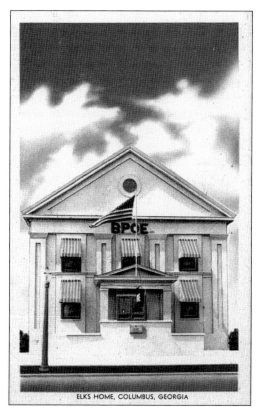

ELKS HOME, COLUMBUS, GEORGIA

ELKS HOME. The Elks occupied the former Broad Street Methodist Church at 1323 Broad, just north of the Swift-Kyle Building after 1947 and into the 1960s. Prior to that it was the *Ledger* office from 1915 until 1931. During World War II it was a service club. After serving as the Elks home, it was a bar before it was demolished in 1990. Country's Barbeque, formerly a bus station, is to the right. Nic Martiniere of Columbus published this card.

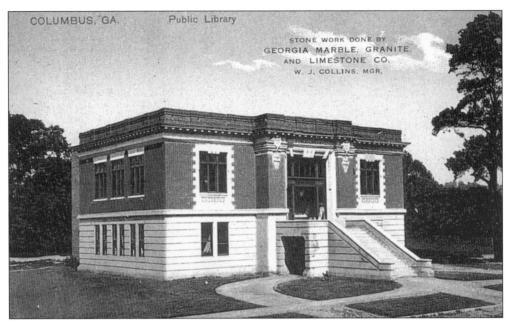

COLUMBUS, GA. Public Library

PUBLIC LIBRARY. The public library was built with a grant from Andrew Carnegie and opened in 1907 at the northern end of Broad Street, just past Fourteenth Street, adjacent to the Muscogee Mills. The address, 1423 Broad, had been the site of houses and was on Mott's Green, an open space used for concerts and other public events. The city sold Mott's Green to the mill in 1947.

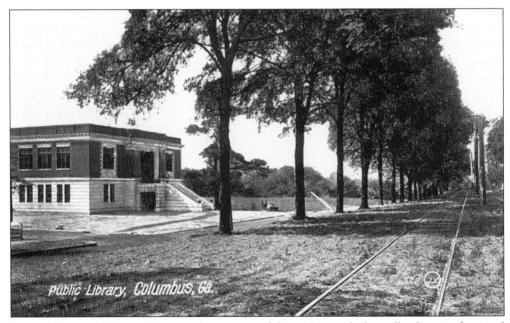

PUBLIC LIBRARY. This *c.* 1910 view shows more of the setting, with the trolley lines in front and Mott's Green to the right. The library operated here until 1950 when the new Bradley Memorial Library opened in Wynnton. After that, this building became part of the Muscogee Mills, and was torn down along with the mill in the fall of 1997 to make way for the Total Systems Campus. (Gift of the W.E. Hill estate.)

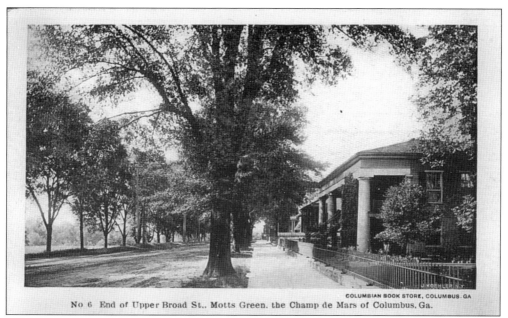

COLUMBIAN BOOK STORE, COLUMBUS. GA

No 6 End of Upper Broad St., Motts Green, the Champ de Mars of Columbus, Ga.

END OF UPPER BROAD. This *c.* 1905 view of the 1400 block of Broad shows the G. Gunby Jordan house that faced the library. Gen. Henry Benning's family home was to the right of the Jordan home. This card is one of a series of 10 published by Charles Pitchford, who ran the Columbian Book Store. Note the caption that this area was the "Champ de Mars" of Columbus.

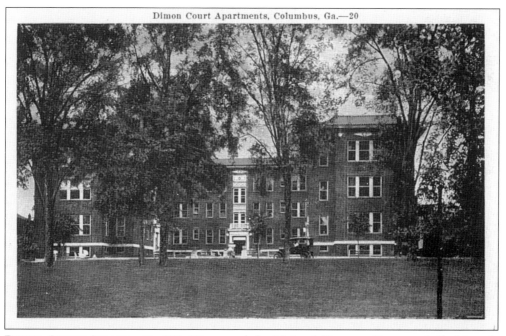

Dimon Court Apartments, Columbus, Ga.—20

DIMON COURT APARTMENTS. J.H. Dimon and the National Showcase Company built this early apartment building in 1920–1921 at a cost of $125,000 and Hickman and Martin designed it. It replaced the Gunby Jordan home (above) and was at 1430 Broad. The apartments faced the Public Library and were torn down in the 1970s for the city bus transfer area, now part of the Total Systems Campus.

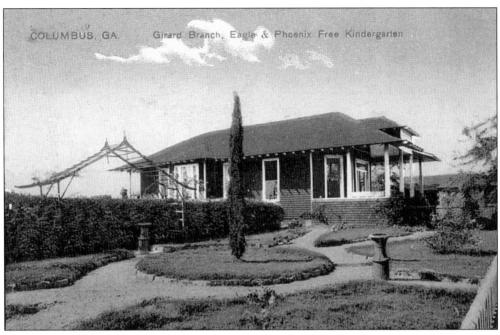

EAGLE AND PHENIX KINDERGARTEN. This is the Girard Branch of the Eagle and Phenix Mills Free Kindergarten, located in Girard (now Phenix City), Alabama, at 211 Second Street.

W. C. BRADLEY CO.
Cotton Factors and Wholesale Grocers.
BRADLEY WAREHOUSES.

COLUMBUS, GA.................................190...

DEAR SIR:

We are in receipt of your favor...................Enclosing.......................for

...Dollars

in settlement of Invoice............................. For which please accept our thanks. Soliciting your further orders, we beg to remain

Yours Truly, **W. C. BRADLEY CO.**

Per...

(71178)

W.C. BRADLEY COMPANY. This United States postal card was sent as a business reply card by the W.C. Bradley Company, located between Tenth and Eleventh Streets on Front Avenue adjacent to the river. The business is still active in the *c.* 1885 building. This card was mailed in 1904, a year before picture postcards first appeared in Columbus. (Courtesy of the Historic Columbus Foundation, Walter Wyatt Collection.)

Three
FIRST AVENUE,
SECOND AVENUE,
AND TENTH STREET

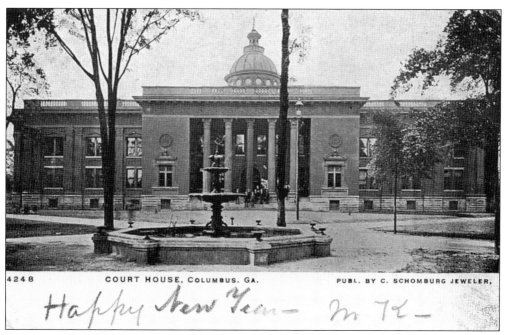

4248 COURT HOUSE, COLUMBUS, GA. PUBL. BY C. SCHOMBURG JEWELER,

MUSCOGEE COUNTY COURTHOUSE. The Muscogee County Courthouse was built between 1895 and 1896, between First and Second Avenues, and Ninth and Tenth Streets, and faced the Springer Opera House on the north. Andrew J. Bryan, a noted courthouse architect, designed the building; it was demolished in 1972 and replaced by the Government Center. Schomburg's published this view in 1905— as one of the first issued for Columbus—and it was sent as a New Year's Card.

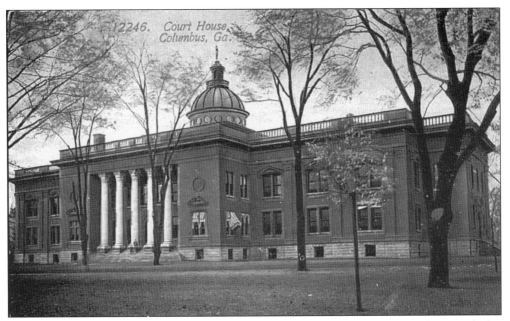

MUSCOGEE COUNTY COURTHOUSE. This *c.* 1910 view shows the park-like setting of the grounds that originally surrounded the courthouse, which also served as city hall. The building was completed in September 1896. One postcard writer wrote of this building, "If this were in some foreign country we would think it grand. We often fail to appreciate the everyday blessings."

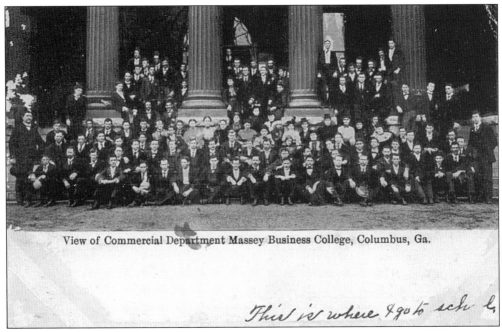

View of Commercial Department Massey Business College, Columbus, Ga.

This is where I go to sch l

MASSEY BUSINESS COLLEGE ON THE COURTHOUSE STEPS. This view of the commercial department of the Massey Business College, a local school that met in a downtown office building, shows the massive size of the courthouse.

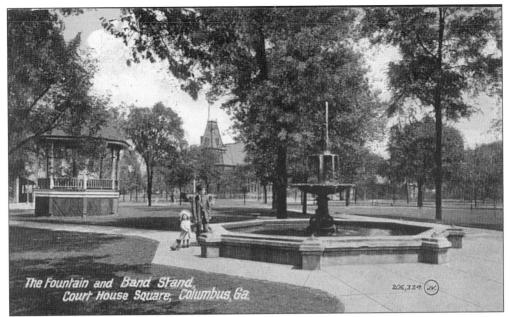

THE FOUNTAIN AND BANDSTAND ON THE COURTHOUSE GROUNDS. This 1909 view looks northeast toward Tenth Street School. The fountain was close to the courthouse steps and was later moved to the median on Broad Street in front of the Goetchius House Restaurant at 405 Broadway. The bandstand was used for concerts and no doubt many political rallies.

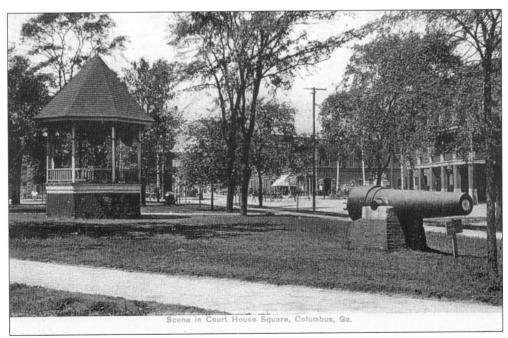

THE BANDSTAND AND THE CANNON ON THE COURTHOUSE GROUNDS. This 1911 view looks northwest with the Springer Opera House on the right. This cannon on the northeast corner and its companion on the northwest corner are now located at the Port Columbus Naval Museum.

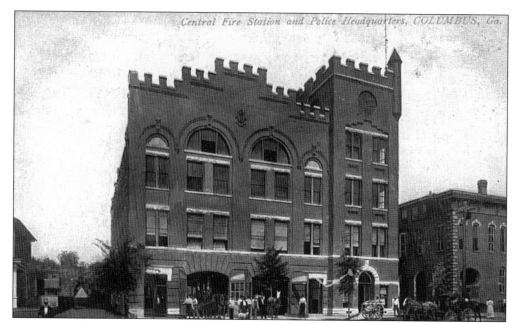

CENTRAL FIRE STATION AND POLICE HEADQUARTERS. The fire station at 931-937 First Avenue faced east toward the county courthouse. Built in 1905 and designed by T. Firth Lockwood Sr., it served as a fire station until 1934 and was later replaced by a new police station, which was replaced by the new RiverCenter for the Performing Arts. The building to the right in this *c.* 1906 view was the Alvin Hotel, later the Verandah Hotel, torn down in 1966.

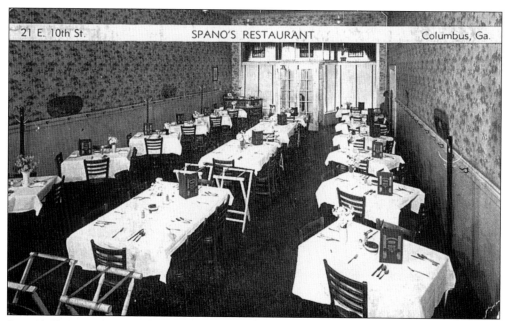

SPANO'S RESTAURANT. This local favorite was at 21 East Tenth Street in the rear of the Rankin House hotel block at the corner with First Avenue. The card indicates it was established in 1893, was the oldest restaurant in Columbus, and at the time was run by Joseph and Salvador Spano. The restaurant space is now the Rankin Quarter restaurant.

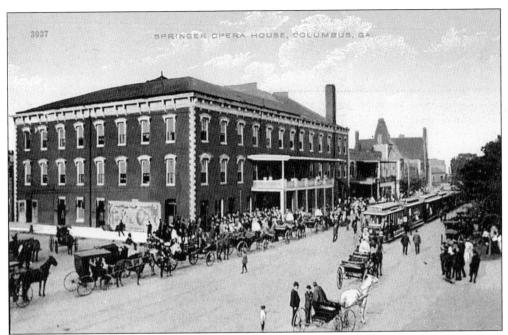

SPRINGER OPERA HOUSE. Built in 1871 as an opera house, the Springer was expanded in late 1901 by adding a hotel portion. Facing south toward Tenth Street and the courthouse, between First and Second Avenues, it remains a local landmark as the site of live theater and other events. This scene shows an event with trolleys coming down the street.

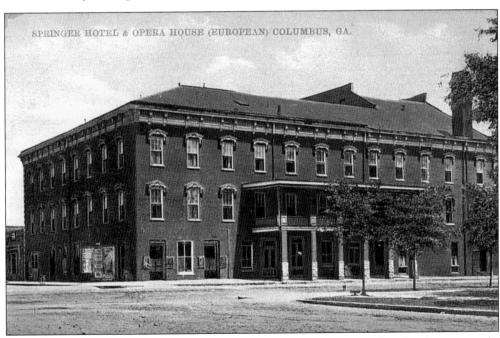

SPRINGER HOTEL, OPERA HOUSE (EUROPEAN). This 1908 card contains this advertisement on the back, "Springer Hotel-European—All rooms have hot and cold running water, steam heat, electric lights, telephones, large sample rooms . . . elevator. H. C. Larzelere, Mgr."

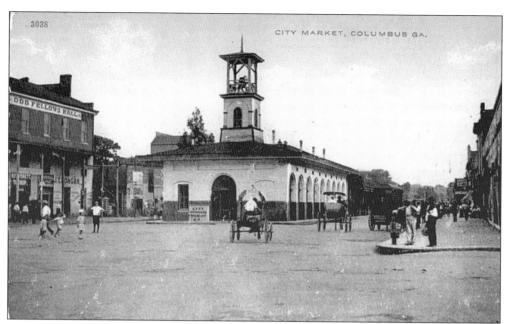

CITY MARKET. The public market was in the First Avenue median between Eleventh Street (this view) and Tenth Street. The bell in the tower once notified citizens of fires. The building on the left in this *c.* 1912 view was the Odd Fellow's Lodge, rebuilt in 1926 and still standing. The public scales in front of the entrance to the market read, "City Standard Weight." Built in the 1870s, the market came down around 1921.

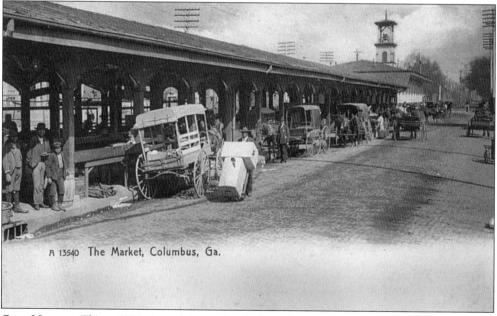

A 13540 The Market, Columbus, Ga.

CITY MARKET. This *c.* 1906 view of the market is from the southeast side near the Springer. One sees the many stalls where meats and vegetables were sold. This view recalls markets in other cities. My grandmother, who often visited her father, J.C. Russell's roofing company nearby, called it the French Market.

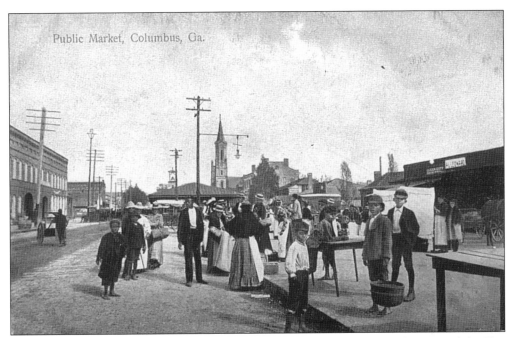

CITY MARKET. This *c.* 1907 view of the market area is from the south end, looking toward the First Presbyterian Church, across the street from the market's entrance. Many of the people in this view are African-Americans who are either shopping or selling their wares at the market.

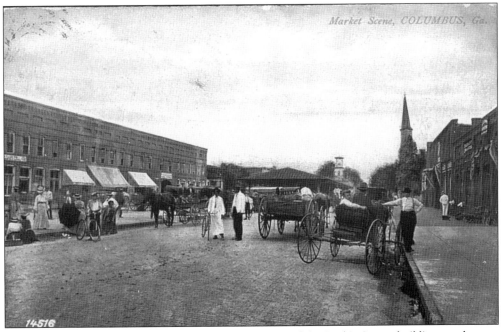

CITY MARKET. This *c.* 1909 view is looking northwest toward the Rankin Square buildings on the west side of First Avenue which survive today and have been restored. As with many postcard views, these four market photographs were published by several different postcard publishers in different colors and hues. (Courtesy of Janet Scroggins.)

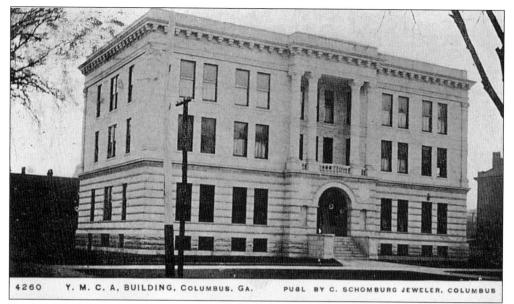

4260 Y. M. C. A. BUILDING, COLUMBUS, GA. PUBL BY C. SCHOMBURG JEWELER, COLUMBUS

THE YMCA. The YMCA (Young Men's Christian Association) was dedicated in 1903 and was a gift of George Foster Peabody (1852-1938), the Columbus-born philanthropist. Designed by local architects Smith and Lockwood, it was said to be the only marble YMCA in the world at the time it was built. The building shown here *c*. 1905 remains the YMCA at 124 Eleventh Street between First and Second Avenues, a half block from where the market was.

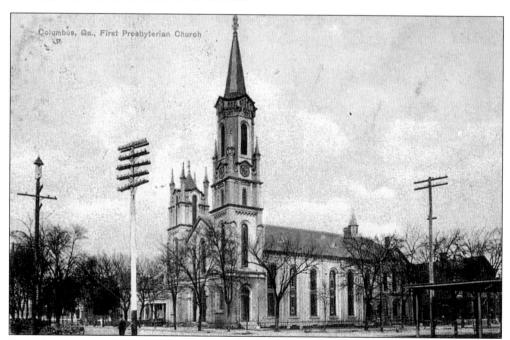

Columbus, Ga., First Presbyterian Church

FIRST PRESBYTERIAN CHURCH. Located at 1100 First Avenue on the northeast corner with Eleventh Street, the congregation was founded in 1830, moved here when this building was constructed in 1862, and rebuilt after an 1891 fire. The church has changed little since this *c*. 1910 view was published in Germany for the W.A. White Company of Columbus, a major postcard distributor.

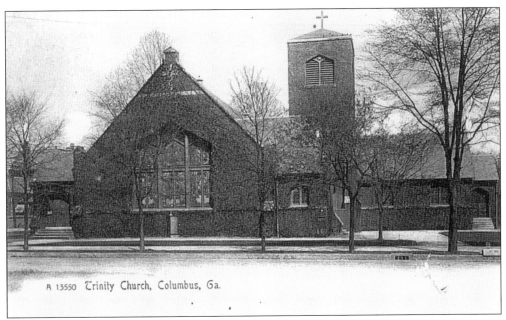

A 13550 Trinity Church, Columbus, Ga.

TRINITY EPISCOPAL CHURCH. This church is located just north of the First Presbyterian Church at 1130 First Avenue. The congregation was founded in 1834 and this building opened in 1891. The church is still active and looks much the same, although there were later additions. An identical card was sent as a Christmas card by the rector in 1905.

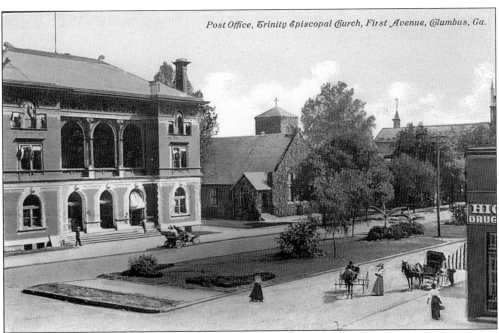

Post Office, Trinity Episcopal Church, First Avenue, Columbus, Ga.

U.S. POST OFFICE AND FEDERAL BUILDING. This 1911 view shows the post office, built in 1895, which stood on the southwest corner of First Avenue and Twelfth Street, next to Trinity Episcopal Church. It was replaced by a new post office built adjacent to it in the rear in 1934. This building was demolished in the 1950s.

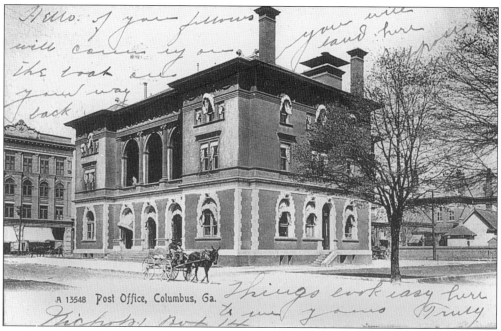

U.S. Post Office. This October 1905 mailing shows the post office with a view toward the Masonic Temple across the street. A home sat to the rear of the post office on the site of its future replacement.

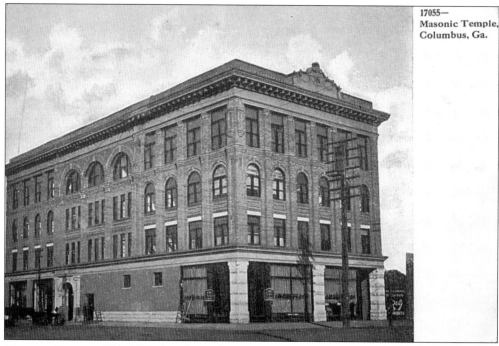

17055—
Masonic Temple,
Columbus, Ga.

Masonic Temple. This 1908 view shows the Masonic Temple at 101 Twelfth Street. Dedicated in 1902, it was designed by the Lockwood Brothers. A new lodge was completed in 1942 on Second Avenue; this building was sold in 1940 to J.E. Flowers and became the Flowers Building. It survives today at the northeast corner of First Avenue and Twelfth Street.

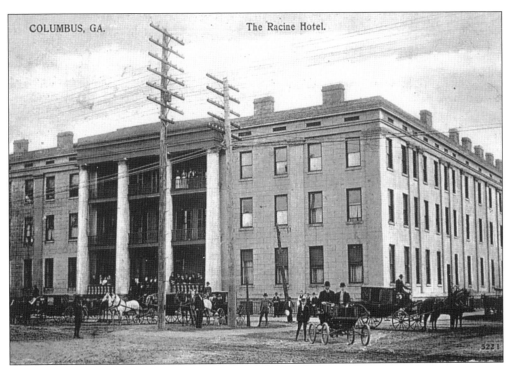

COLUMBUS, GA. The Racine Hotel.

THE RACINE HOTEL. A 1907 view shows the hotel—formerly the Perry House—at the northeast corner of First Avenue and Thirteenth Street. Owner Ed Racine later changed the name. It was demolished in 1944, and later became the site of the First National Bank and then the First Union Bank headquarters.

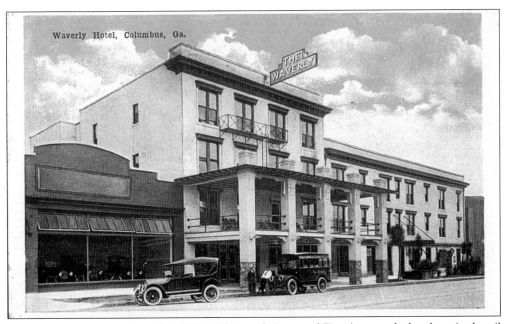

Waverly Hotel, Columbus, Ga.

THE WAVERLY HOTEL. Opened in 1914 at Thirteenth Street and First Avenue, the hotel survived until 1985; it is now the Carmike Building. Jack Walton managed the hotel—one card stated it was "air conditioned throughout." To its left is an auto showroom that in 1918 was the Overland Sales Company.

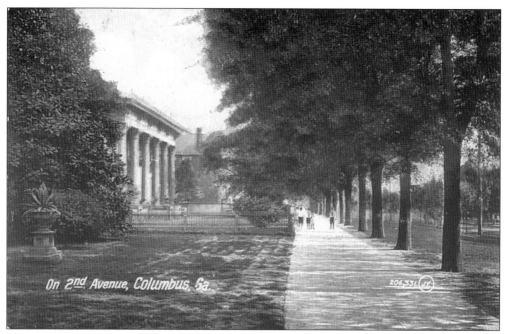

SECOND AVENUE. This 1909 view shows the lushness of Second Avenue looking south from the intersection of Fifteenth Street from in front of the James Rankin House. On the left is the Illges House at 1428, now the Lower Chattahoochee Regional Development Center. An earlier card called this view the Elysian Fields of Columbus. (Courtesy of Historic Columbus Foundation, Walter Wyatt Collection.)

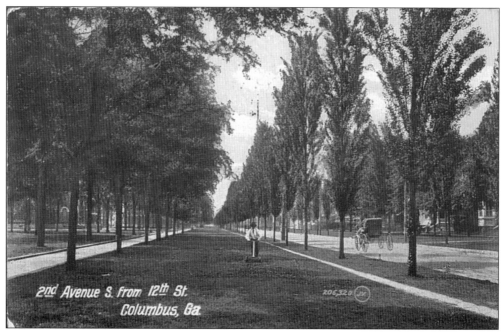

SECOND AVENUE SOUTH FROM TWELFTH STREET. In this 1911 view one sees the tree-lined median of the street with the First Baptist Church and St. Luke Methodist Church on the left.

THE RALSTON HOTEL. This early view of the hotel, which opened in 1914, is from the architect's rendering. The architectural firm of Ludlow and Peabody of New York City designed the building, which was named for J. Ralston Cargill, head of the local hotel corporation. Located at the northeast corner of Second Avenue and Twelfth Street, it faces the First Baptist Church.

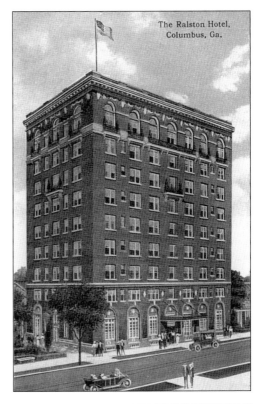

The Ralston Hotel, Columbus, Ga.

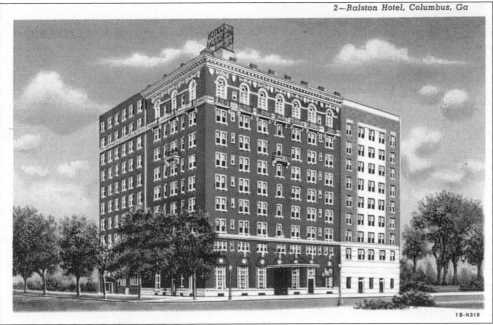

2—Ralston Hotel, Columbus, Ga

THE RALSTON HOTEL. This 1941 view of the Ralston shows it with the 1919 addition on the left and the 1940 addition on the right. It continued as a hotel until 1975. Since then it has been a senior citizens home known as the Ralston Towers. Oscar L. Betts Jr. was the hotel manager for many years.

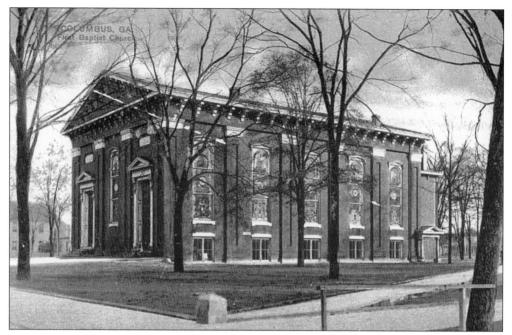

First Baptist Church. This *c.* 1905 view shows the church before the columned front portico was added in 1909. Located at the southeast corner of Twelfth Street and Second Avenue, the congregation was granted this lot in 1829. The church has been located on this corner ever since.

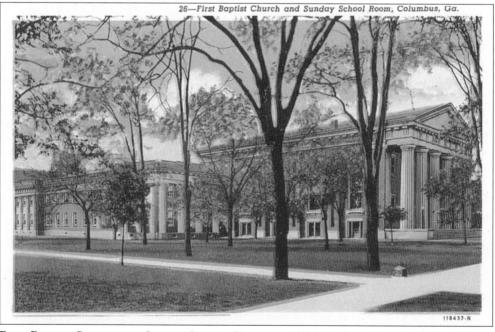

First Baptist Church and Sunday School Building. This 1928 view of the church from the east side shows the columned front portico and the 1923-1924 Sunday school addition to the rear. Today the church has an active congregation.

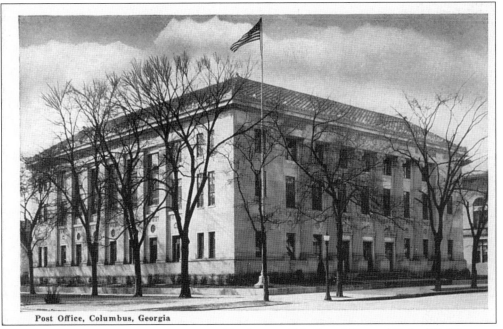

Post Office, Columbus, Georgia

U.S. POST OFFICE AND COURTHOUSE. In 1934 the new U.S. Post Office and Federal Building was opened just behind the earlier post office. This building, located at the southwest corner of Second Avenue and Twelfth Street, remains the local federal building and a branch post office.

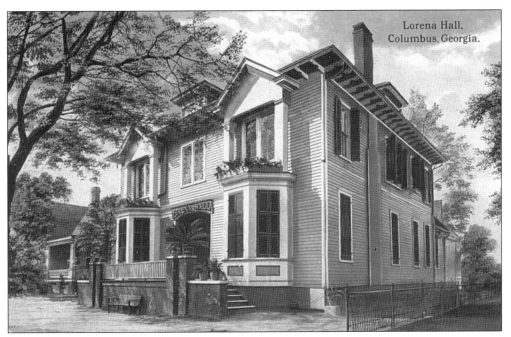

Lorena Hall,
Columbus, Georgia.

LORENA HALL. This house at 1133 Second Avenue was on the west side of the block of Second Avenue between Eleventh and Twelfth Streets, c. 1915. As Lorena Hall, a private girls' school, it operated from around 1912 until becoming an apartment building by 1928. The new Masonic Temple was built in 1942 just to the right of the former school. The site is now part of the First Presbyterian Church.

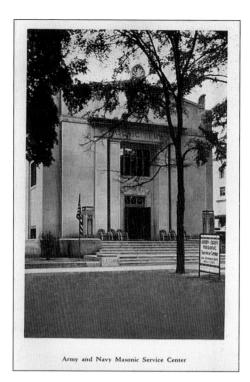

Army and Navy Masonic Service Center

MASONIC TEMPLE. This "new" Masonic Temple was opened in 1942 at 1127 Second Avenue. It has served since then as the meeting place for many organizations, both for men and women, including the Masons, and the Eastern Star. During World War II it served as a Masonic Service Center for military personnel; note the sign in this view.

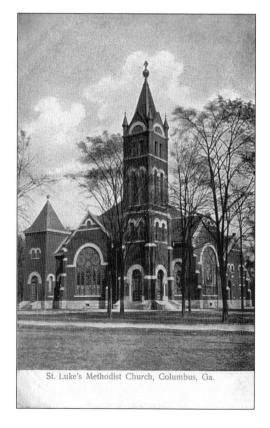

St. Luke's Methodist Church, Columbus, Ga.

ST. LUKE METHODIST CHURCH. St. Luke Methodist Church, shown here *c.* 1911, has been located on the southern half of church square, sharing it with First Baptist, since it was granted the lot in 1828. This building was built between 1897 and 1898 and faced Second Avenue at the corner of Eleventh Street. It was diagonally across the intersection from the YMCA.

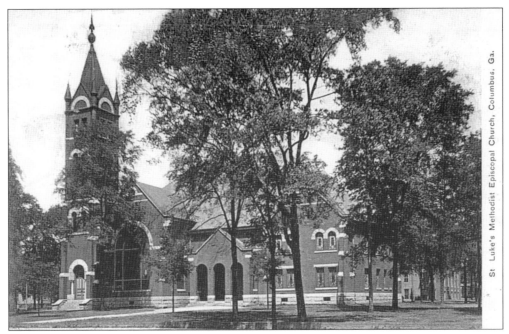

St. Luke's Methodist Episcopal Church, Columbus, Ga.

ST. LUKE METHODIST CHURCH. This is the Eleventh Street facade of the earlier St. Luke's. The church burned on Mother's Day, May 10, 1942, and was totally destroyed.

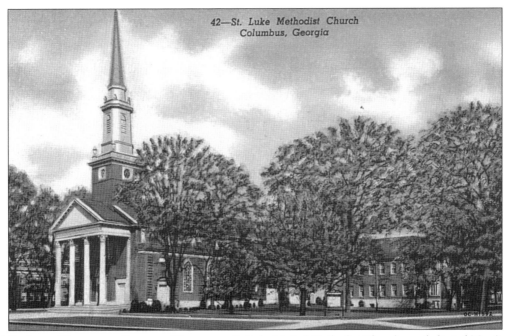

42—St. Luke Methodist Church
Columbus, Georgia

ST. LUKE METHODIST CHURCH. The current St. Luke United Methodist Church was dedicated May 9, 1948, just six years after the devastating fire. This 1950 view shows the front portico, which faces Second Avenue. The church remains an active congregation here.

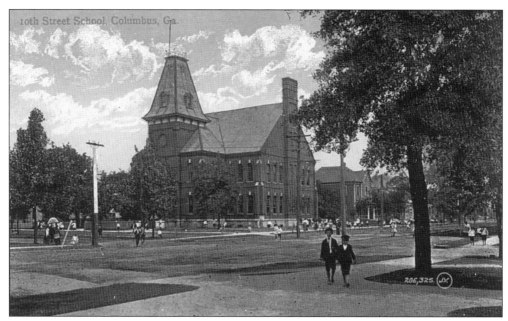

TENTH STREET SCHOOL. This elementary school for white students was at 1004 Second Avenue, the northeast corner with Tenth Street. The school faced the side of the Springer Opera House and, diagonally, the county courthouse. This 1911 view is from the courthouse grounds. Built in 1888, the school was torn down in 1934 and replaced by a fire station. This corner was the site of the second Presbyterian Church until 1862.

CHASE CONSERVATORY OF MUSIC. This music school was located just southeast of the above school at 220 Tenth Street at Third Avenue. This 1909 view is looking southwest. The school was started by George W. Chase and continued by his son, Louis T. Chase, until the latter's death in 1942. The school offered experienced teachers in the departments of music, art, and oratory, and had a large auditorium for performances. It was torn down in 1969.

Four

THIRD AVENUE, FOURTH AVENUE, AND TWELFTH STREET

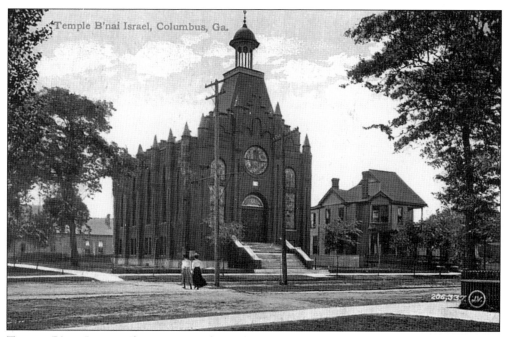

TEMPLE B'NAI ISRAEL. This 1912 view shows the synagogue at 314 Tenth Street, on the southwest corner of Fourth Avenue. This Jewish synagogue was dedicated in 1889 and used until 1958, when they moved to the new temple at 1617 Wildwood Avenue and this building was demolished. The site is now a restaurant.

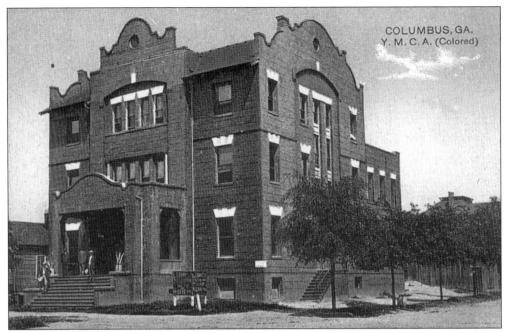

YMCA ("COLORED"). The Ninth Street Branch YMCA was located at 521 Ninth Street at the northwest corner of Fifth Avenue. This view is *c.* 1909, about the time it was built using funds from George Foster Peabody. The building collapsed in December 1963. The site is part of the parking facility for the police/jail complex. This is a rare African-American postcard for Columbus, and the only one found for this book. (Gift of John McKay Sheftall.)

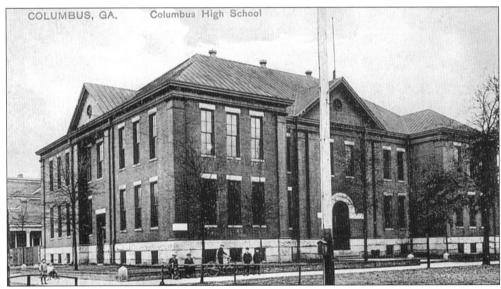

COLUMBUS, GA. Columbus High School

COLUMBUS HIGH SCHOOL. This 1909 view is the first public high school for white students, which opened in 1898. Designed by the Lockwood Brothers, it is located at 320 Eleventh Street at the southwest corner with Fourth Avenue (Veterans Parkway). It served as the high school until 1926 when the present-day Columbus High School opened on Cherokee Avenue. This building then became an elementary school. Today it is owned and used by a law firm.

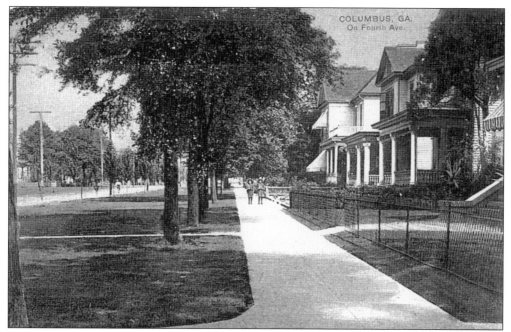

FOURTH AVENUE. This 1909 view shows Fourth Avenue, now Veterans Parkway, when it was a residential street. Note the large front yards, the trees, and the wide sidewalk.

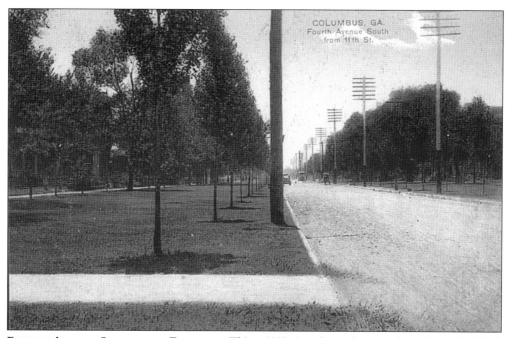

FOURTH AVENUE, SOUTH FROM ELEVENTH. This *c.* 1915 view shows the street from Columbus High School looking south. At this time the street was only 132 feet wide. Note the multi-tiered utility poles that have begun to appear. (Gift of Vickie Harville.)

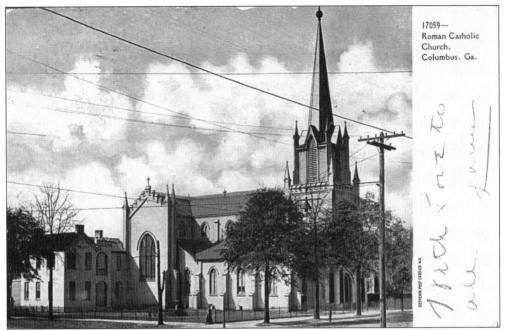

HOLY FAMILY CATHOLIC CHURCH. The Church of the Holy Family Roman Catholic Church was incorporated in 1831 first as the Church of Saints Philip and James. The name changed when they moved here. The current building shown in this *c*. 1906 view was dedicated May 2, 1880, and is located at 320 Twelfth Street, on the south side between Third and Fourth Avenues.

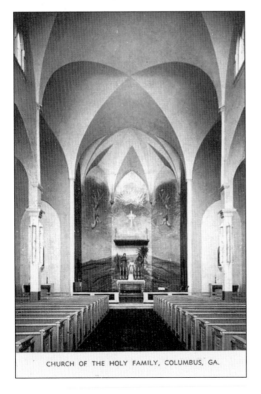

CHURCH OF THE HOLY FAMILY, COLUMBUS, GA.

INTERIOR OF HOLY FAMILY CATHOLIC CHURCH. This rare interior view of a church was published locally by Columbus Office Supply Company. The interior looked like this from 1945 to 1964.

68

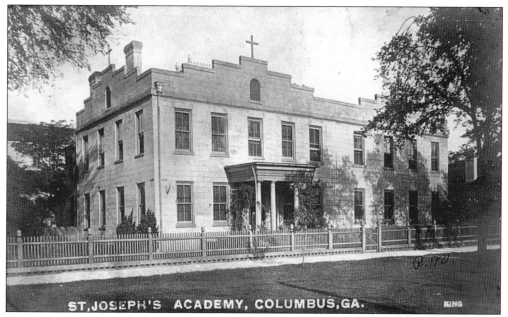

SAINT JOSEPH'S ACADEMY. This school was located adjacent to the Church of the Holy Family on the Third Avenue side. Originally the James Shorter House, the house was converted to a school *c.* 1870 and was run by the Sisters of Mercy until 1964. It was torn down in 1970. This *c.* 1913 real photo card was by Columbus photographer Ralph S. King.

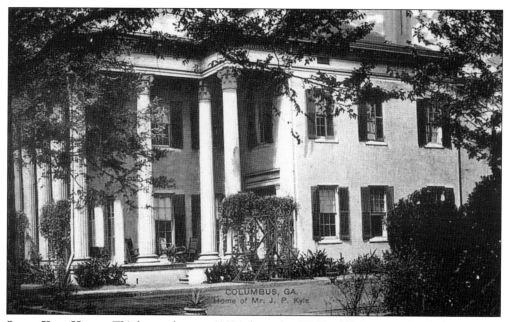

SWIFT-KYLE HOUSE. This house shown *c.* 1913 is located at 303 Twelfth Street, at the northeast corner with Third Avenue, across from the Catholic Church. This antebellum mansion has had many owners including George Parker Swift and his daughter and son-in-law, Adelaide and James P. Kyle. It was last used as a family home in 1956, and for years it housed the Columbus Travel Bureau. Owned by descendant J. Kyle Spencer, it awaits a new use.

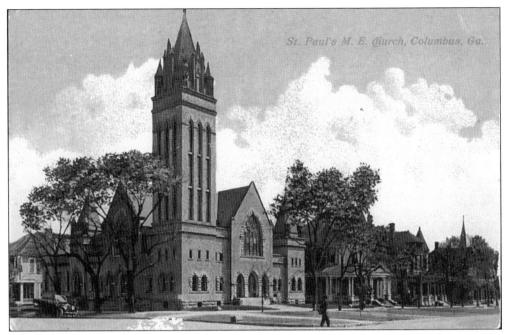

SAINT PAUL'S METHODIST CHURCH. This *c.* 1914 view shows the church facing Third Avenue at the southeast corner of Thirteenth Street. This church was built in 1902, replacing an earlier building that burned September 13, 1901. The congregation remained here until they moved in 1952 to a new facility on Wildwood Avenue. This building was demolished by 1959 for the S&S Cafeteria building, now Columbus Productions. (Courtesy of Historic Columbus Foundation, Dexter Jordan Collection.)

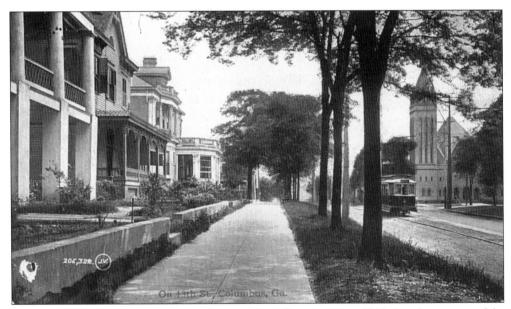

THIRTEENTH STREET LOOKING EAST TOWARD SAINT PAUL'S. This *c.* 1910 view shows some of the fine homes that graced the neighborhood. On the left is the Martin J. Crawford House, an antebellum structure once owned by a prominent attorney, at 209 Thirteenth Street. It was demolished in January 1949. The site is now behind Regions Bank. Note the trolley.

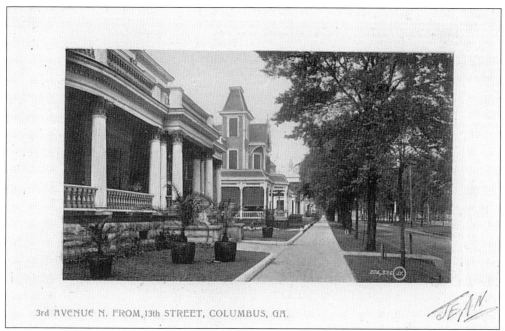

3rd AVENUE N. FROM, 13th STREET, COLUMBUS, GA.

THIRD AVENUE LOOKING NORTH AT THIRTEENTH STREET. This *c.* 1915 view shows several houses on this northwest corner, diagonally across from St. Paul's. The house immediately on the left was that of Arthur Bussey and family. The site was later John A. Pope Motor Company, now occupied by Ray's Uptown Body Shop. (Courtesy of Mike Helms.)

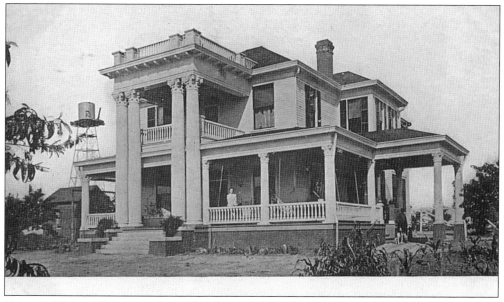

MYSTERY HOUSE. This postcard was printed around 1905 or 1906, just as view cards began to appear in Columbus. This card was found in two separate postcard collections, each having formerly been owned by the John Blackmar Family, who lived at 1336 Third Avenue. Since neither card is identified by publisher or by any writing, it is believed to be the house of a friend, neighbor, or relative. (Courtesy of Historic Columbus Foundation, John Blackmar Collection.)

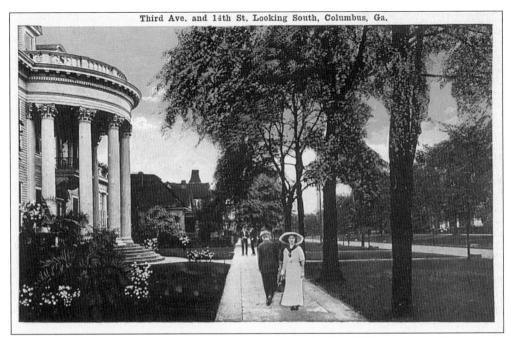

THIRD AVENUE LOOKING SOUTH AT FOURTEENTH STREET. In this *c.* 1915 postcard, the house on the left was built in 1884 for John Blackmar at 1336 Third Avenue and enlarged with neoclassical additions in 1912. His daughter Susie Blackmar Ellis and her husband John T. Ellis and family lived there until her death in 1981. It is now a funeral home.

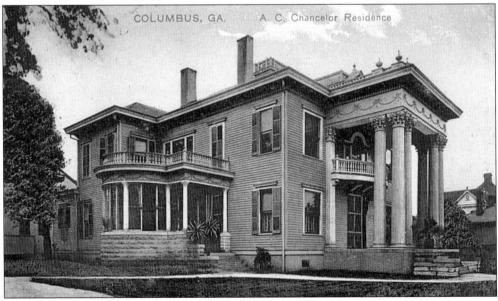

COLUMBUS, GA. A. C. Chancelor Residence

A.C. CHANCELLOR HOUSE. Located at 1401 Third Avenue, on the northwest corner with Fourteenth Street, this house was diagonally across from the Blackmar-Ellis House. This *c.* 1909 view shows the house built by 1907 for A.C. Chancellor, founder of the local clothing store. By 1918 it was the home of James A. Lewis and his wife, Robena Bass Lewis, and remained in that family until after 1942. It was later demolished. Magnolia & Ivy, on the site now, is in a house that was moved there.

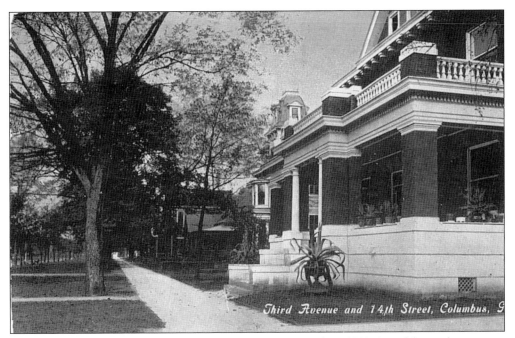

THIRD AVENUE LOOKING NORTH AT FOURTEENTH STREET. This *c.* 1910 view of the northeast corner of the intersection, just across the street from the previous two views, shows the Ethelred Philips House at 1400 Third Avenue, and behind it the Bullard-Hart House, *c.* 1887, at 1408 Third Avenue. Both houses survive; Dr. Lloyd Sampson and his wife Gloria restored the latter.

THIRD AVENUE, EAST SIDE. This *c.* 1914 view appears to be the east side of Third Avenue between Fifteenth and Fourteenth Streets. Around that time the Bradley, Nuckolls, and Edge families lived on this block. The Bullard-Hart and Philips houses appear at the far right.

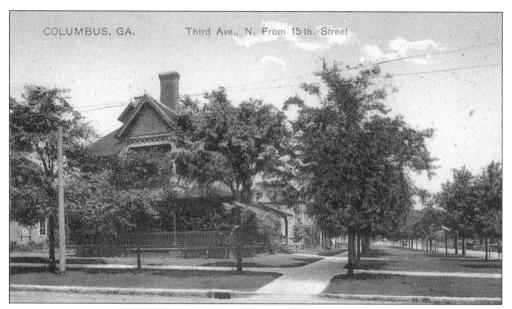

COLUMBUS, GA. Third Ave., N. From 15th. Street.

THIRD AVENUE LOOKING NORTH AT FIFTEENTH STREET. In this *c.* 1915 view of the northwest corner of the intersection, on the left is the Henry R. Goetchius House at 1501 Third Avenue. After his 1925 death it became the home of his niece Mary McKinley and her husband Samuel Marshall Wellborn. The Wellborns previously lived at 204 Eleventh Street, also a family home, which was moved to 405 Broadway to be the Goetchius House restaurant.

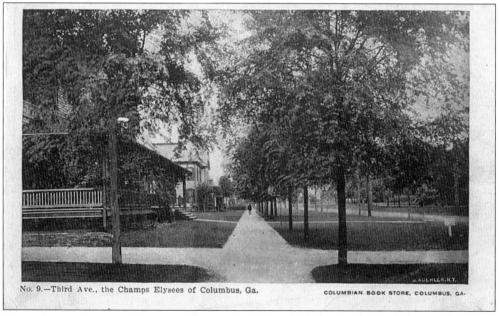

No. 9.—Third Ave., the Champs Elysees of Columbus, Ga. COLUMBIAN BOOK STORE, COLUMBUS, GA.

THIRD AVENUE LOOKING NORTH AT FIFTEENTH STREET. This is an earlier, *c.* 1905, view of the same intersection and house as the one above. Note the caption "the Champs Elysees of Columbus," which is one of several captions in a series of 10 cards by the Columbian Book Store of Charles Pitchford that compared Columbus views to famous places. The house was later demolished, although other houses on this block survive today.

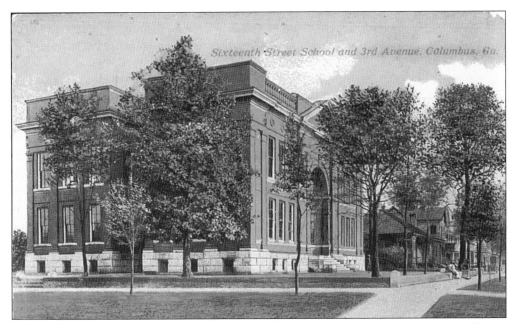

SIXTEENTH STREET SCHOOL. This 1914 view shows the elementary school that was built in 1893 for white students. It operated in that capacity—later being renamed in 1951 the Woodall School—until 1974. Located at 1532 Third Avenue, for many years it has been the House of Mercy. The architect was Gottfried Norrman of Atlanta.

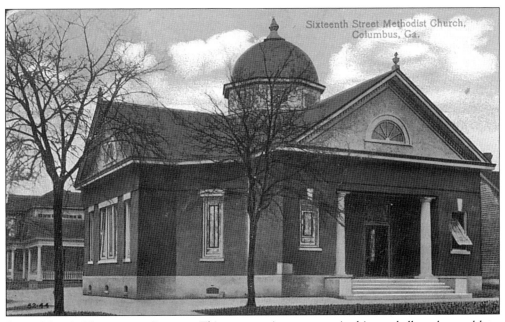

SAINT MARK'S METHODIST CHURCH. This congregation was organized in antebellum days and later worshiped in the Broad Street Methodist Church. They moved here around 1912 to 1913 and built this church at 1605 Third Avenue, at the northwest corner with Sixteenth Street. By 1914 the church was known as Saint Mark Methodist. The congregation moved in 1978 to a new building on Whitesville Road. Having been used by other faiths, this building is now for sale.

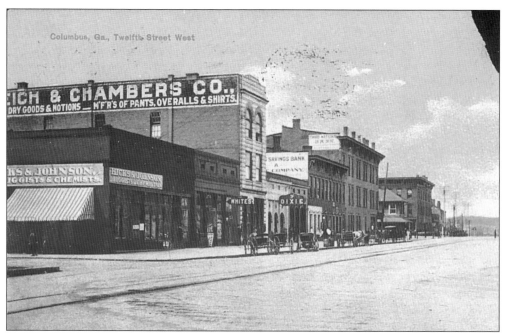

TWELFTH STREET LOOKING WEST FROM FIRST AVENUE. In this *c.* 1911 view mailed *c.* 1920 by a soldier at Camp Benning, one looks toward the Transfer Station on Broad. Note Hicks and Johnson, druggists and chemists, on the corner, and White's, the firm that sold this card locally. The Dixie Theater can also be seen in the middle of the block at number 16. In 1908 Doc Brooks operated it. (Courtesy of Mike Helms.)

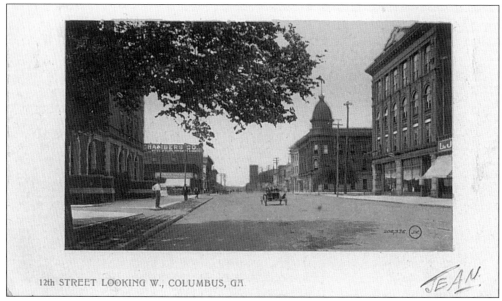

TWELFTH STREET LOOKING WEST FROM SECOND AVENUE. This pre-1914 view was made a block east of the previous one, with the post office on the left, and the Columbus Investment Company Building (later the Murrah/Empire Building) on the right with its domed turret. Across First Avenue is the Masonic Temple (after 1940 the Flowers Building).

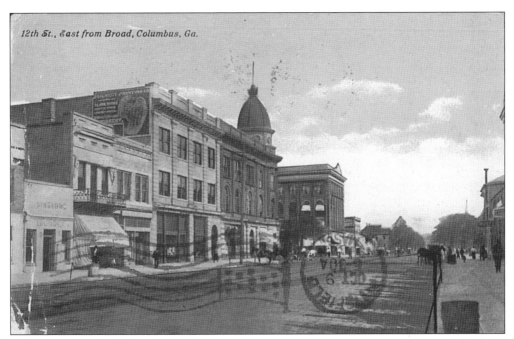

12th St., East from Broad, Columbus, Ga.

TWELFTH STREET LOOKING EAST FROM BROAD STREET. This 1911 view shows several blocks of Twelfth Street from Broad before the Ralston Hotel was built. The first full building on the left housed the Sing Lung Laundry, later Yee Lee, a Chinese laundry, at number 9 Twelfth Street.

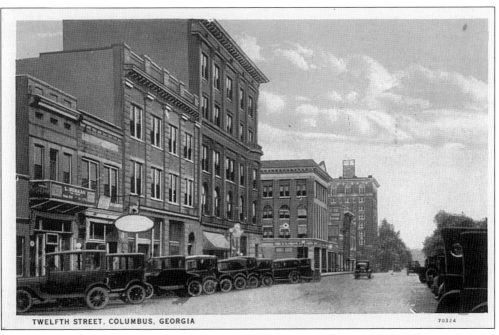

TWELFTH STREET, COLUMBUS, GEORGIA 70324

TWELFTH STREET LOOKING EAST FROM NEAR BROAD STREET. This *c.* 1916 view shows two major changes: the Ralston Hotel, which opened in 1914, is in the distance, and the Columbus Investment Company has lost its domed turret as part of its expansion from three to five floors and has become the Murrah Building/Empire Building. Most of this view survives today. (Courtesy of Mike Helms.)

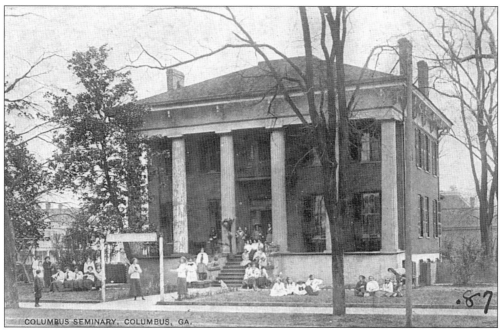

COLUMBUS SEMINARY, COLUMBUS, GA.

COLUMBUS SEMINARY. Located at 416 Twelfth Street at the southwest corner of Fifth Avenue, this was the William Beach House when the area was a fashionable residential street. By 1912 it became a girls' school known officially as the Columbus Seminary, which lasted until around 1920. This *c.* 1912 view shows many of the students on the grounds. It was only a block from the depot.

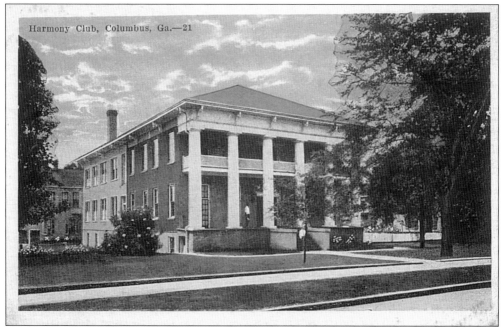

Harmony Club, Columbus, Ga.—21

THE HARMONY CLUB. By 1925 416 Twelfth Street had become the Harmony Club, a private Jewish social club, and served in that capacity until 1954. The building was later demolished and on this site now is the 416 Office Building.

TWELFTH STREET LOOKING EAST AT FIFTH AVENUE. This 1908 view shows the home of Thomas E. Blanchard at 1200 Fifth Avenue, northeast corner with Twelfth Street. It was across the street from the Beach-Seminary-Harmony Club property. In the distance are the tower of the 1881 railroad depot, and the roof of the Union Depot. Note the early street light near the house. The site is now vacant.

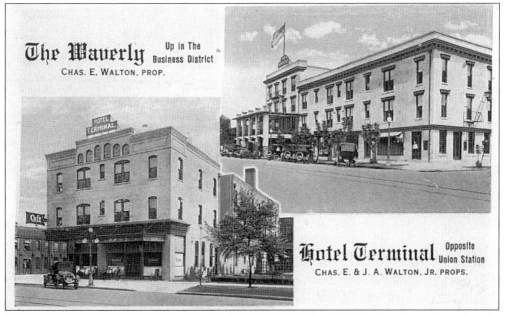

THE HOTEL TERMINAL/TERMINAL HOTEL. The Terminal Hotel, built in 1913, was located at the southwest corner of Twelfth Street and Sixth Avenue, opposite the depot. At the time of this 1921 card Charles E. and J.A Walton Jr. operated it as well as the Waverly Hotel. By 1942 it was the Cardinal Hotel; it was demolished in 1988. The site is now a parking lot. Golden's Foundry is seen in the background.

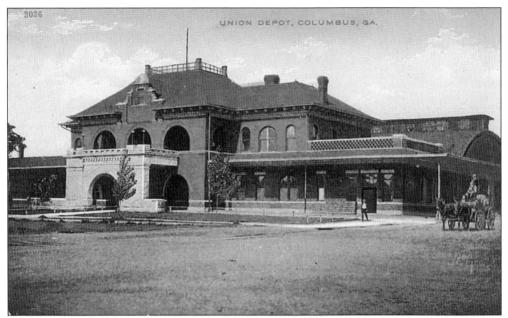

UNION DEPOT. Built in 1901 at 1200 Sixth Avenue for the Central of Georgia Railroad, it served as the union station for all lines. Bruce and Morgan, architects of Atlanta, designed the building. The curved roof to the rear is the train shed. Passenger service ended in 1971. Total System Services restored the depot, shown here around 1912, in 1989. The Columbus Chamber of Commerce recently purchased it. (Courtesy of Historic Columbus Foundation, Dexter Jordan Collection.)

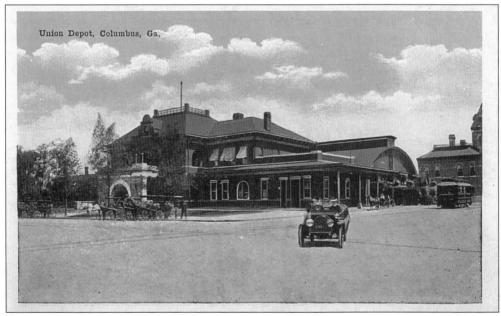

UNION DEPOT. This view, mailed in 1918, shows three types of transportation, besides the trains that cannot be seen. There are horse-drawn wagons in front of the station, an automobile in the foreground, and the trolley at the side of the depot. The earlier 1881 depot in the right background was demolished in 1986. The message on this card is similar to many, "How are you? I am all O.K."

Five

LINWOOD, ROSE HILL, AND GREEN ISLAND

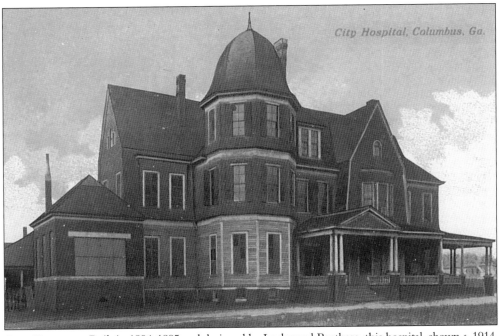

CITY HOSPITAL. Built in 1894–1895 and designed by Lockwood Brothers, this hospital, shown *c.* 1914, was at 721 Fifteenth Street on property that became the Goo-Goo Restaurant. It was between the Dudley Lumber Company and the Swift Mills, just south of Linwood Cemetery. The hospital faced the railroad tracks and was replaced in 1915 by the new city hospital north of this location. Black patients were treated in the left rear wing.

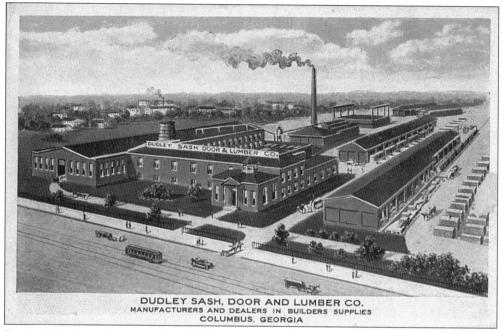

DUDLEY SASH, DOOR AND LUMBER CO.
MANUFACTURERS AND DEALERS IN BUILDERS SUPPLIES
COLUMBUS, GEORGIA

DUDLEY LUMBER COMPANY. The building supply company, shown here in 1919, was between Fifteenth Street and Linwood Boulevard (Sixteenth Street). The site is now the city METRA bus headquarters. (Courtesy of Mike Helms.)

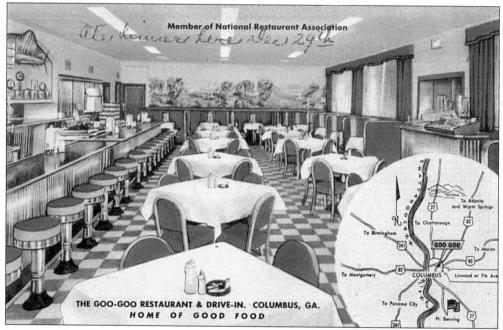

THE GOO-GOO RESTAURANT & DRIVE-IN. COLUMBUS, GA.
HOME OF GOOD FOOD

THE GOO-GOO RESTAURANT AND DRIVE-IN. This restaurant, founded elsewhere in town, opened in January 1941 at 700 Linwood Boulevard. J. Albert Snipes, who copyrighted the name in 1940, operated it. The name Goo-Goo originated with Joe Penner, a radio comedian. The restaurant burned in 1965 and was replaced by the Goo-Goo Carwash, which is still in business at other locations.

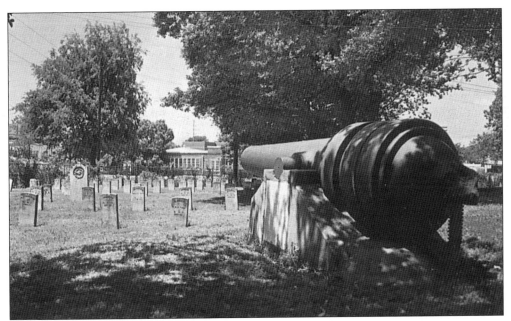

LINWOOD CEMETERY. The city's oldest cemetery was established in 1828 in the city's original plan and named Linwood in 1894. This view is of the Confederate cannon looking over the Confederate section of the cemetery. In the distance is the Claflin School, an African-American school, part of the school system administration today. The Historic Linwood Foundation assists the city with the cemetery's preservation and restoration. (Courtesy of the Historic Columbus Foundation.)

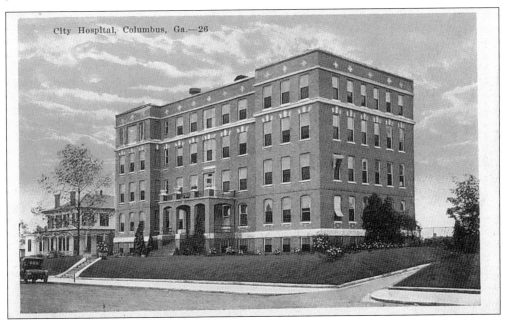

City Hospital, Columbus, Ga.—26

CITY HOSPITAL. This hospital is shown shortly after it opened in 1915 on Nineteenth Street at Seventh Avenue, just north of Linwood Cemetery. Eugene Wachendorff of Atlanta designed the hospital. Over the years it was expanded and replaced, and the site is now part of the Medical Center complex. The hospital faced north.

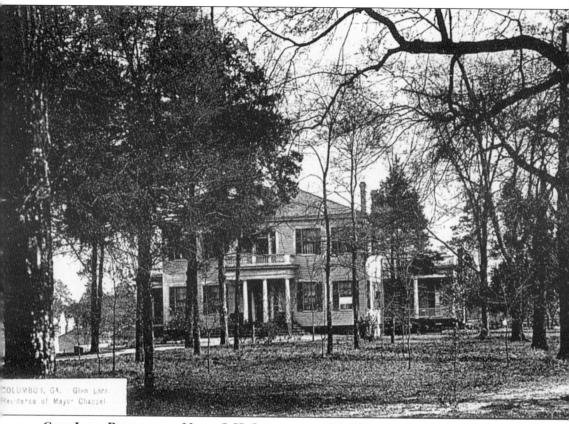

COLUMBUS, GA. Glen Lora.
Residence of Mayor Chappel

GLEN LORA, RESIDENCE OF MAYOR L.H. CHAPPELL, C. 1908. This antebellum home, located at 2000 Talbotton Road, at Eighth Avenue, faced north. The mayor and his family, including his daughter Loretto who was later the city librarian, moved here around 1906. The house survived until the 1940s when it was replaced by a nurses training building, part of the City Hospital/Medical Center complex which now occupies a large part of the area.

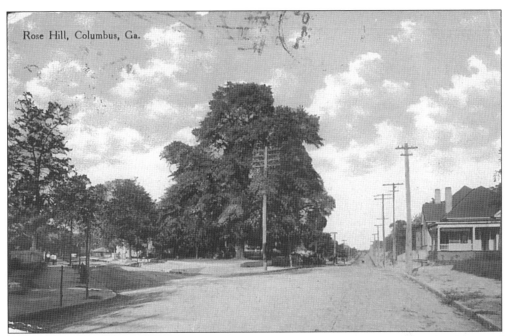

ROSE HILL. This 1911 view is only a few blocks west of Glen Lora along Talbotton Road and is one of several views of the popular suburb of Rose Hill, which began in the nineteenth century as a place where many prominent families had homes.

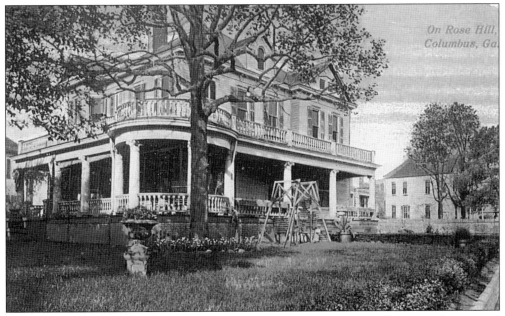

ON ROSE HILL, THE ROY E. MARTIN HOUSE. This house was at 621 Twentieth Street at the northeast corner with Hamilton Road. It was built *c.* 1889 and later enlarged by this 1914 view. In 1910 Hattie Lou Miller married Roy E. Martin Sr., founder of the Martin Theater Chain, and they lived here. The house was demolished in the 1980s. To the right of the house, and not seen in the card, was the home known as Rosemont.

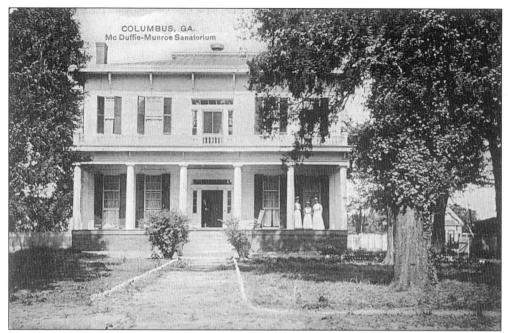

McDuffie-Munroe Sanatorium. This hospital was located at 2015 Sixth Avenue, just south of the Rose Hill School. This *c.* 1914 view shows the former Grigsby E. Thomas House, one of the major antebellum homes in the area, after it became a hospital. Note the nurses on the front porch. By 1942 it became Oaklawn Chapel, a funeral home, and has been demolished.

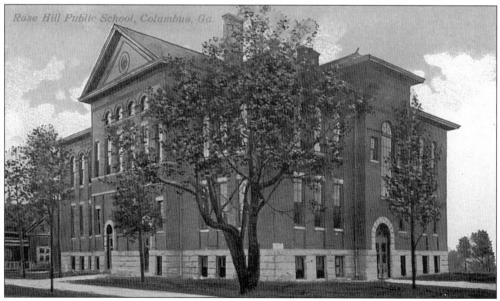

Rose Hill Public School. The school shown here, *c.* 1914, is located at 435 Twenty-first Street, just two blocks west of Hamilton Road. This elementary school for white children was built in 1900 and designed by T.W. Smith, a local architect. Originally two houses were on the block, later the school yard, between the school and the Rose Hill Methodist Church. Now it is the Rose Hill Center for the school system.

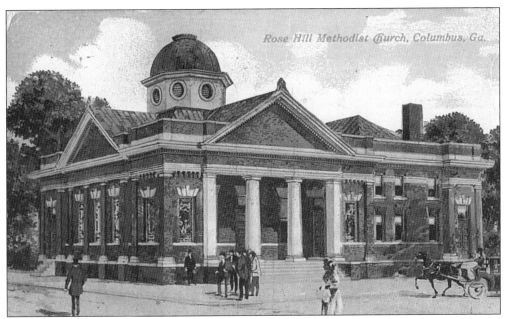

ROSE HILL METHODIST CHURCH. The church is located at 2101 Hamilton Road, at the northeast corner of Twenty-first Street and Sixth Avenue; it opened in 1909. This card is a copy of the 1908 rendering by local architect T.W. Smith. The church is still active as the Rose Hill United Methodist Church.

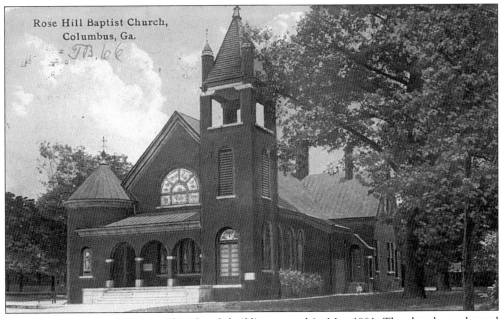

ROSE HILL BAPTIST CHURCH. This church building opened in May 1901. The church was located at 2100 Hamilton Road, at the southeast corner with Twenty-second Street. After a new sanctuary was built in 1968, this building was demolished after 1977. The church is still active in the new building. William F. Thomas, local postcard collector, exchanged this card in 1912 with a fellow collector in North Dakota.

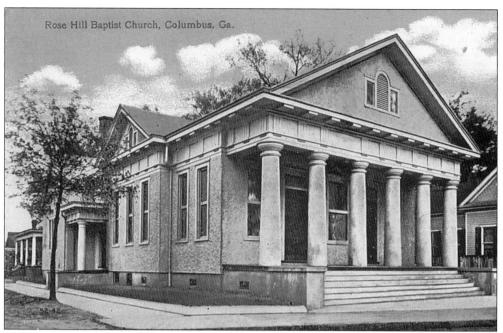

ROSE HILL PRESBYTERIAN CHURCH. Located at 2216 Hamilton Road, the church was erroneously identified as the Baptist Church in this *c*. 1914 view. Built by 1900 and designed by T.W. Smith, it served as a Presbyterian church until the 1930s when it became the Rose Hill Church of Christ into the 1960s. Today it is used by another faith. (Courtesy of Gary Doster.)

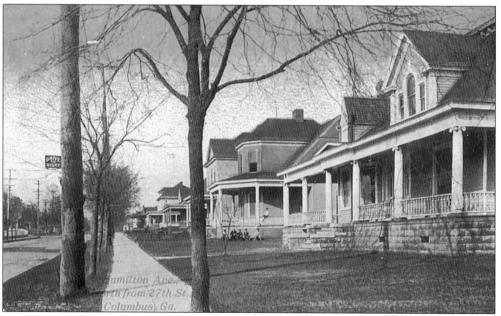

HAMILTON ROAD AT TWENTY-SEVENTH STREET. This *c*. 1914 view shows the houses at the northeast corner of this intersection, the center of Rose Hill. The house on the immediate right is no longer standing, while the others remain, starting at number 2714 Hamilton Road. At the time of this view, the Beard, Perkins, Boyce, and Smith families occupied the houses shown.

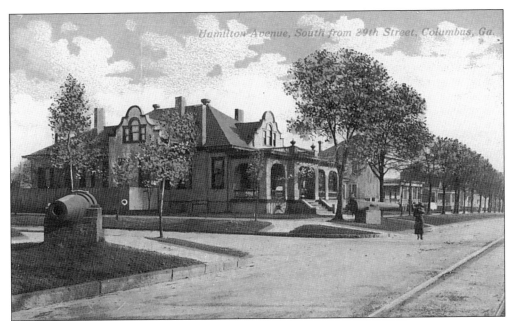

HAMILTON ROAD, SOUTHEAST FROM TWENTY-NINTH STREET. This *c.* 1914 view is the same block as the previous card, from the other direction. The two Civil War cannons, taken in 1942 for the scrap metal drive, were returned in 1943 after protests by several organizations. Today they are at the Port Columbus Naval Museum. The c.1912 house in the center, built by architect T.W. Smith as his home, survives at 2850 Hamilton Road. (Courtesy of Gary Doster.)

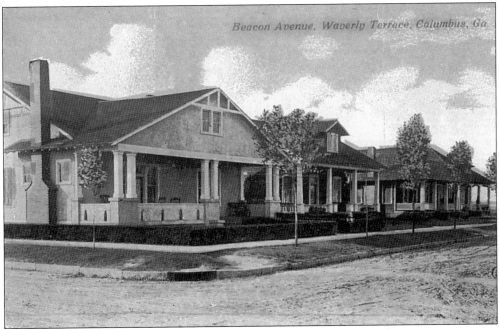

BEACON AVENUE, WAVERLY TERRACE. This *c.* 1914 view shows a typical street in the new Waverly Terrace subdivision, begun by the Jordan Company in 1906. These three houses still stand at the northwest corner of Twenty-ninth Street and Beacon as numbers 2901, 2903, and 2911.

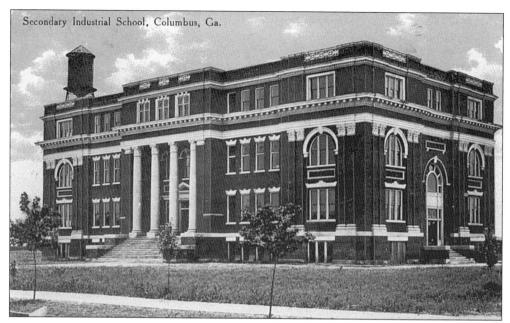

Secondary Industrial School, Columbus, Ga.

SECONDARY INDUSTRIAL SCHOOL, C. 1910. Located at 1112 Twenty-ninth Street in the Waverly Terrace neighborhood and built in 1906, it was said to be the first industrial or vocational high school in the country. It served as a high school until 1937, when Jordan Vocational High School opened. "Old Industrial" became a junior high and now serves as the Academic Success Center for the school system.

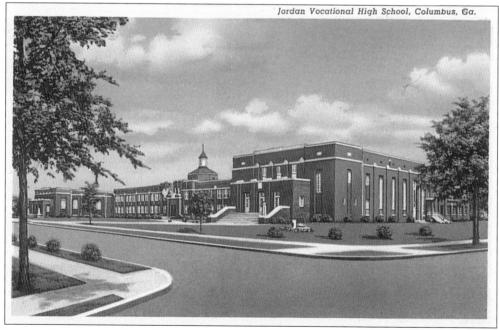

Jordan Vocational High School, Columbus, Ga.

JORDAN VOCATIONAL HIGH SCHOOL. Located at 3200 Howard Avenue, about a half-mile from its predecessor (above), the school opened in 1937; the auditorium was added in 1939. The Confederate cannons once on the lawn are now at the Port Columbus Naval Museum, and the school remains active as Jordan High School.

90

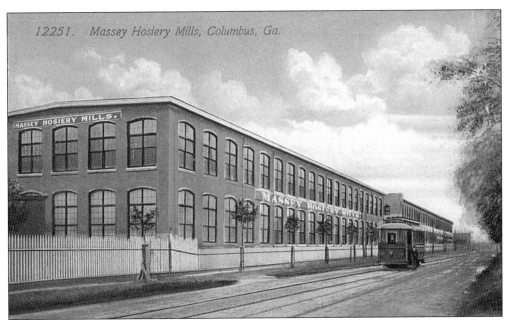

MASSEY HOSIERY MILL. This *c.* 1914 view is of the Twelfth Avenue side looking southeast. The mill is located at the northeast corner of Talbotton Road and Twelfth Avenue. Later it became part of the Jordan Mills at Jordan City, and still stands. It opened around 1905 adjacent to the Perkins Mill and was first called the Topsy Hosiery Mill. Note the trolley. (Courtesy of Historic Columbus Foundation, Dexter Jordan Collection.)

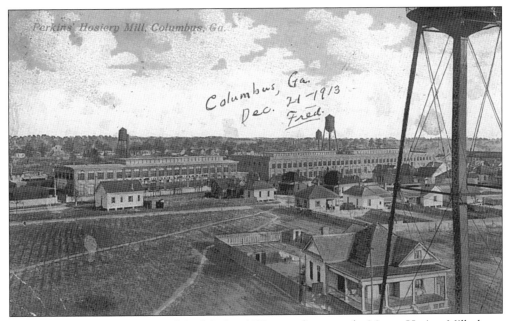

PERKINS HOSIERY MILL. This mill, built before 1905, was adjacent to the Massey Hosiery Mill, above, and they both later became the Jordan Mills in 1937. This view was taken from near the water tower at the Secondary Industrial School nearby. Note the mill workers' housing immediately across the street from the mill. This view was mailed in 1913.

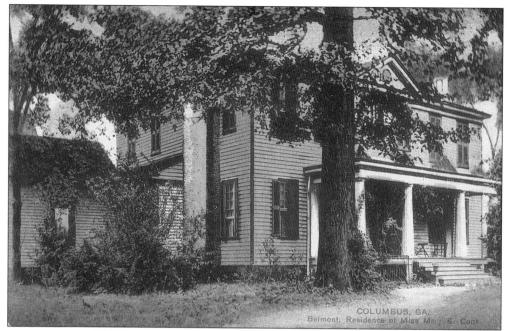

BELMONT, RESIDENCE OF MISS MARY E. COOK. This antebellum home, shown here *c.* 1908, was part of the estate of James Cook (1823-1901). The house was located at the northwest corner of Seventh Avenue and Belmont Street. When Cook's daughter Mary E. "Mollie" Cook died in 1928, she left the house to the First Presbyterian Church, and it survived in reduced circumstances until the 1960s.

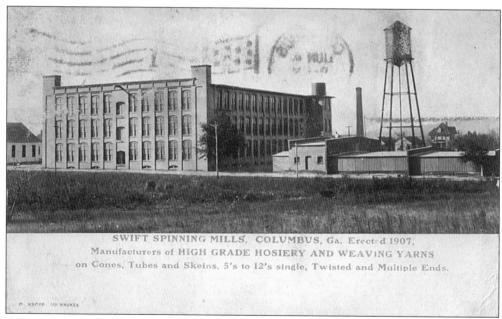

SWIFT SPINNING MILLS. Located at 3224 Second Avenue, this mill opened in 1907 and is still located there. The company mailed this card to clients in 1908 to solicit business, stating "Our facilities are unexcelled for furnishing the best yarn at the lowest prices." The other "Swift Mills," Swift Textile Mills, is on Sixth Avenue.

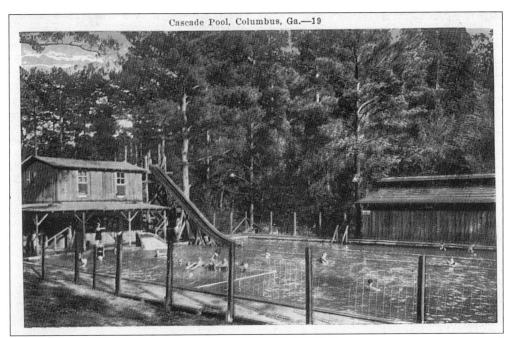

CASCADE POOL. This pool, shown in a *c.* 1923 view, flourished in the 1920s and 1930s. It was located off River Road near present-day Cascade Road in the Green Island Hills section, north of the city.

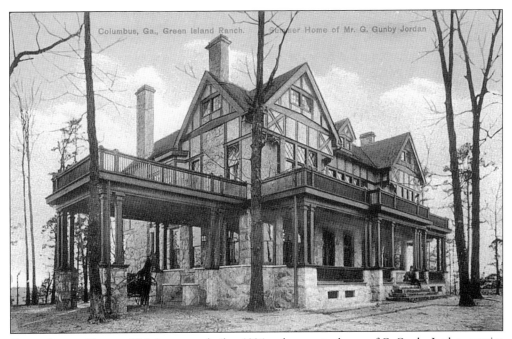

Columbus, Ga., Green Island Ranch. Summer Home of Mr. G. Gunby Jordan

GREEN ISLAND RANCH. This house was built *c.* 1906 as the country home of G. Gunby Jordan, a major Columbus industrialist. It burned *c.* 1920 and a similar home rebuilt on the site during 1921 that survives at 6551 Green Island Drive, the home of Nora Jordan Garrard and her husband, Gardiner Garrard. This card was mailed in 1908.

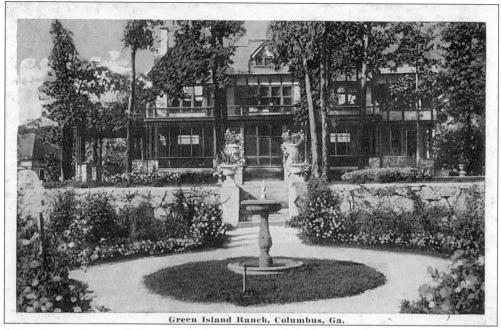

GREEN ISLAND RANCH. This is a view looking west toward the first house from the tulip garden.

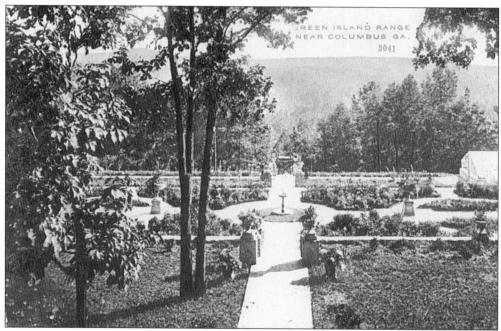

GREEN ISLAND RANCH. This is a *c.* 1912 view from the house looking eastward through the garden shown in the previous card toward the magnificent vista the owner had. The house site was said to be the highest point in Muscogee County.

Six
WYNNTON, WILDWOOD, AND ST. ELMO

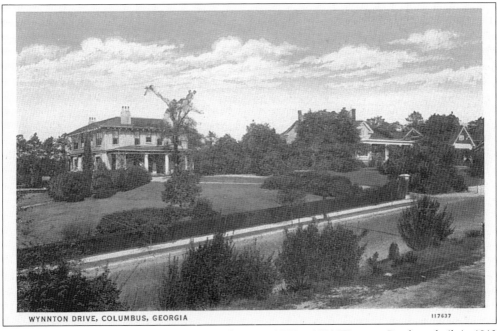

WYNNTON DRIVE, COLUMBUS, GEORGIA 117637

WYNNTON DRIVE. The W.C. Bradley House shown in 1927 at 1251 Wynnton Road was built in 1912 for B. S. Miller and designed by A. Ten Eyck Brown of Atlanta. At the death of Bradley, a major local industrialist, in 1947, the eight-and-a-half-acre estate became city property. Out of the estate came a museum, the new public library, and the headquarters of the school board.

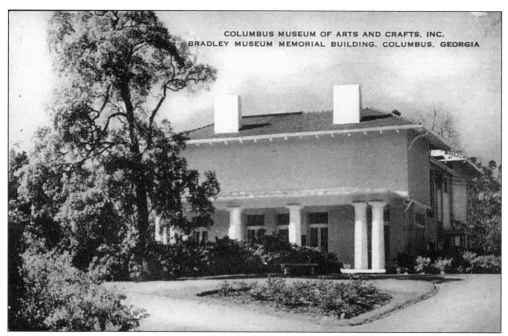

THE COLUMBUS MUSEUM OF ARTS AND CRAFTS. This museum opened in 1953 at 1251 Wynnton Road and, after several expansions, is now called the Columbus Museum. The museum hosts traveling exhibits as well as housing a permanent local exhibit, and highlighting locally-born achievers such as artist Alma Thomas and architect Philip Trammell Shutze of Atlanta. The Bradley home is still visible in the design of the building. (Courtesy of Mike Helms.)

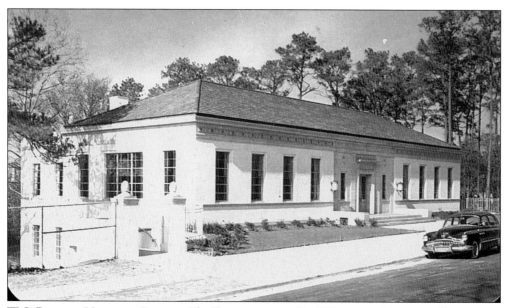

W.C. BRADLEY MEMORIAL LIBRARY. The library was opened in 1950 on what became Bradley Drive. It was built in the midst of the Bradley Estate's gardens, which had been designed by the Olmsted Brothers, nationally known landscape architects. After 50 years as the main public library, a new library is being planned further east on Macon Road.

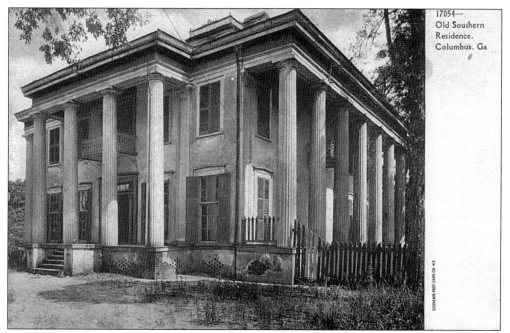

WYNN-BUTLER HOUSE. Now the Christian Fellowship Association (CFA) and located at 1240 Wynnton Road, the house is seen *c.* 1906 before it was moved closer toward Wynnton Road. It was built *c.* 1830s by Col.William L. Wynn (1799-1868) for whom this area, Wynnton, originally a separate community, was named. Colonel Wynn left Columbus *c.* 1850 and died in New Orleans in 1868 where he was buried. Note the card's caption as "Old Southern Residence."

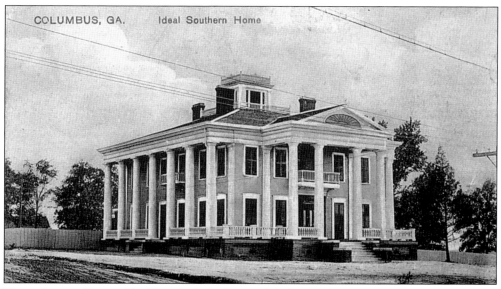

WYNN-BUTLER HOUSE. The Hines Holt family owned the house when J.T. Cooper bought the 18-acre estate in 1905 and moved the house. While the exact date of the move is unknown, the earliest postmark for this card made after the move is July 1908. The Overlook subdivision near the house was created in 1927. The house became the Christian Fellowship Association headquarters in 1958 and is used for receptions and other events.

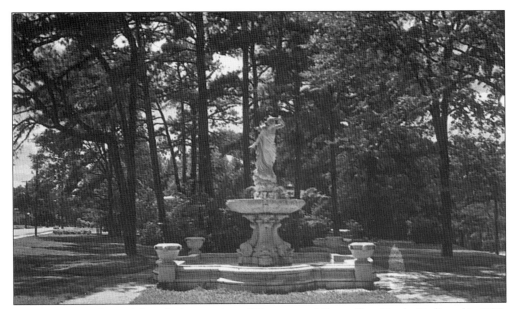

SARLING PARK. This park is at the intersection of Wynnton and Buena Vista Roads. Dedicated in 1929, the park with its statue and fountain was given to the city as a memorial to Leonora Myers Sarling (*c.* 1861-1928) by her family. Mrs. Sarling was a practitioner in the Christian Science Church when she died in 1928 from a car wreck. She and her husband, Solomon Sarling, are buried in Magnolia Cemetery in their hometown of Augusta.

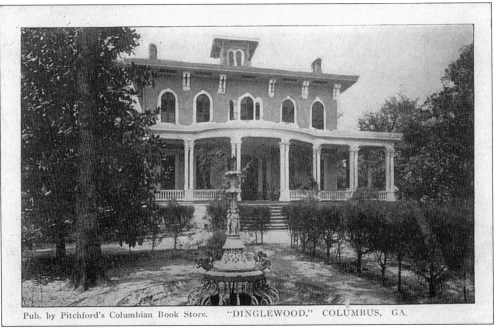

Pub. by Pitchford's Columbian Book Store. "DINGLEWOOD," COLUMBUS, GA.

DINGLEWOOD. This is a *c.* 1908 view of the house at 1429 Dinglewood Drive that was built in 1859 by Joel Early Hurt. At his widow's death here in 1899, it passed to her kinsman Miss Frances Adams and later co-owner, Annie G. Hinde. Since 1950 the house has been owned by Lloyd G. Bowers Jr. (1912-1994) and family. A neighborhood was created out of the estate grounds in 1916.

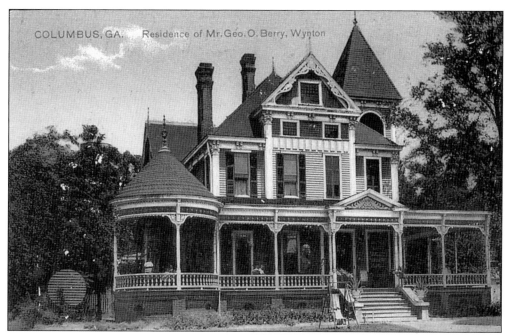

THE GEORGE O. BERRY SR. HOUSE. Located at 1707 Wynnton Road, this elaborate Queen Anne–style house was built in 1895 with plans by T.W. Smith. George Berry Sr. (1847-1923) ran the Berry Brick Company at the time this postcard was made around 1908. The site is now a fast-food restaurant. The house next door, 1617 Wynnton Road, former home of Turner E. Berry, is now a gift shop. (Courtesy of Mike Helms.)

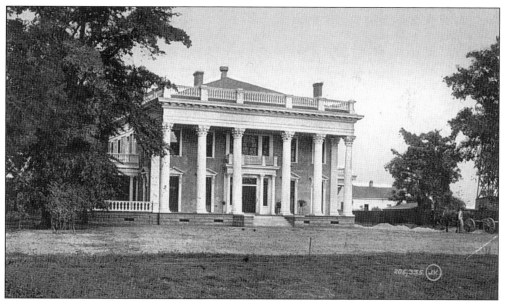

THE EPHRAIM P. OWSLEY HOUSE. Located at 1831 Wynnton Road, just south of present-day Owsley Avenue, this neoclassical–style house was built around 1908 for Owsley, a banker, who died in 1934. This view was mailed in 1910. The house was torn down and the site is currently a large apartment complex.

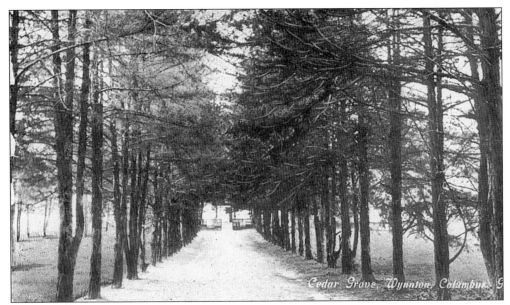

CEDAR GROVE C. **1912.** This road (now Cedar Avenue) leads from Wynnton Road north to 2039 Thirteenth Street and the house known as "The Cedars." Col. John Banks built the house in 1836. The property has never left the family, having been owned in direct succession by the Peacock and Dimon families, and now John and Lucy Tresp Sheftall. (Courtesy of Mike Helms.)

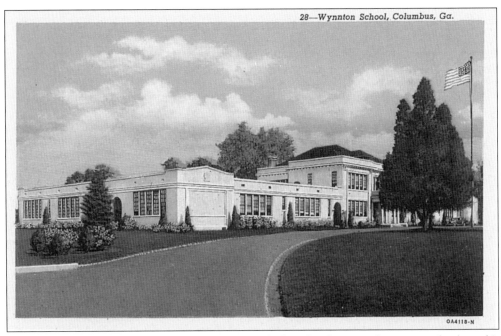

WYNNTON SCHOOL. Located at 2303 Wynnton Road, there has been an elementary school on this property since the Wynnton Academy was incorporated in 1837. The original one-room schoolhouse remains today as the school library. The current building was built in 1923 and became part of the city school system when Wynnton was incorporated into Columbus in 1925. This card was the first non-vacation postcard purchased by the author in the late 1950s.

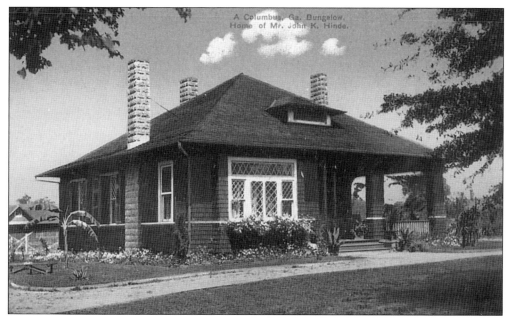

JOHN K. HINDE HOUSE. This Craftsman bungalow at 1531 Wildwood Avenue was such an unusual house type for Columbus that it was included in a postcard series in 1908 with local mansions. John K. Hinde (1870-1952), a bank cashier, moved in 1918 to Atlanta. Later owners were the John G. Ball family in the 1920s and 1930s, and Mary Ann Flowers and husband Edward W. Neal, from 1953 until the 1990s. The owners since 1995 are Ed and Denise Kendust.

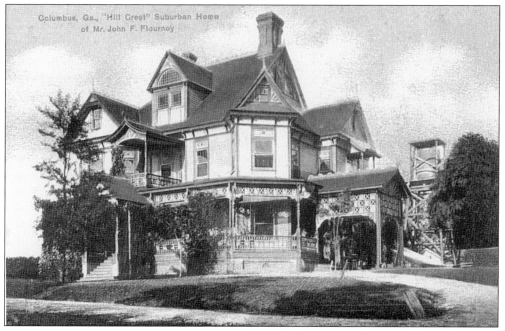

HILLCREST. This house at 1652 Carter Avenue was built *c.* 1890 by John Francis Flournoy (1847-1936), a realtor and developer of the area, including Wildwood Park nearby. Designed by L.E. Thornton, it remained in the Flournoy family until the 1990s and is now the home of Mrs. Susan Schley Gristina.

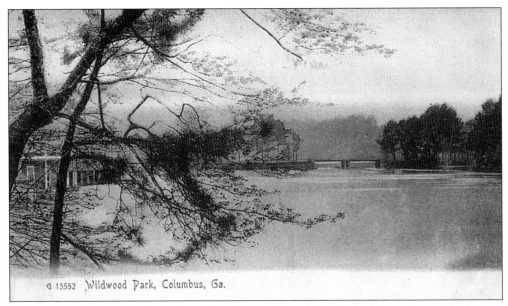

G 13552 Wildwood Park, Columbus, Ga.

WILDWOOD PARK. This park was located in the area bounded today by Forest Avenue, Eighteenth Avenue, Seventeenth Street, and Garrard Street. Created by John F. Flournoy, it operated from the 1880s until *c.* 1919 after which it was sold to the city in the 1920s. The lake was drained, and the area became known as "Lakebottom" as it is today—a city park and athletic field for the nearby high school.

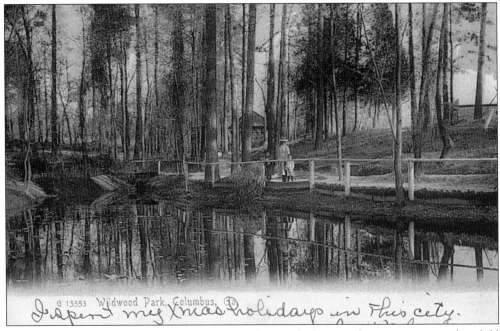

G 13553 Wildwood Park, Columbus, Ga.

WILDWOOD PARK. In this view, issued *c.* 1905 along with the one above, a woman and a child stroll along the side of the lake with a gazebo in the background. In one reminiscence, a local writer recalled the butterfly shed with benches at the park entrance, the zoo with alligators in it, and the annual Easter egg hunt. There were also outdoor silent movies shown. Dancing and skating were enjoyed in the pavilion.

102

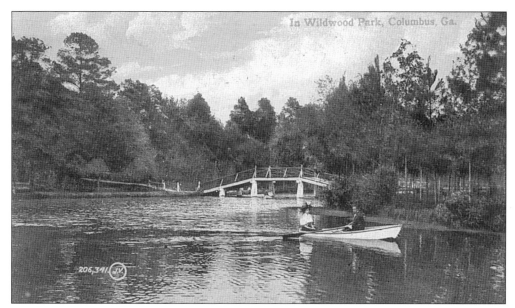

WILDWOOD PARK. Here is the bridge that led to one of the park's four islands, where the bands played. The park was accessible by the trolley line that circled it. The outings in the park were great occasions for local families for decades. The park closed in 1919 due to the flu epidemic and in the 1920s was bought by the city and the lake was drained.

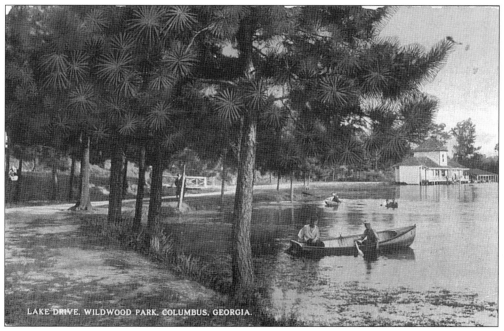

WILDWOOD PARK. This *c.* 1913 view shows Lake Drive, which bordered the lake. In the distance is the bathhouse and near it was the sliding board for swimmers, both at the south end of the park at what is now Seventeenth Street. After the lake was drained and the new Columbus High School opened in 1926 on high ground on the east side, the park buildings remained abandoned until they burned down in the late 1920s.

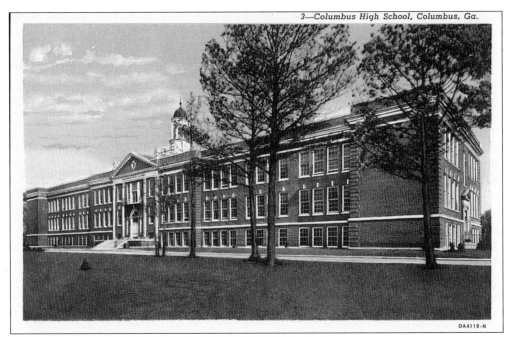

OA4119-N

COLUMBUS HIGH SCHOOL. The new high school opened September 17, 1926, at 1700 Cherokee Avenue, after the city took possession of Wildwood Park and the lake was drained. Restored after a 1981 fire, the school remains a high school.

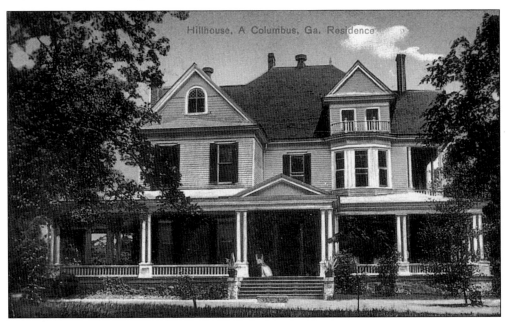

Hillhouse, A Columbus, Ga. Residence

HILLHOUSE. This *c.* 1908 card shows the house at 1510 Twentieth Street that faced south toward Wildwood Park. William S. Shepherd, a bachelor, willed it in 1924 to the local orphans' home to be the Anne Elizabeth Shepherd Orphans' Home, named for his mother. The orphans' home remained here until it moved in 1966 to Double Churches Road and this house was torn down. The site became the Bradley Center. Mrs. Sarah Flewellen, who lived here with her brother, mailed this card to a friend.

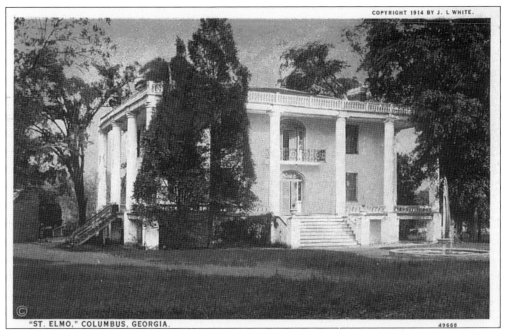

"ST. ELMO," COLUMBUS, GEORGIA. 49668

ST. ELMO. Built in 1832 by Col. Seaborn Jones, this house is located at 2807 Eighteenth Avenue. Formerly known as "Eldorado," the house was renamed in 1878 after the novel *St. Elmo*, published in 1866, and written by his wife's niece, Augusta Evans Wilson. J.L. White of the White Company, who produced the vast majority of early Columbus postcards, copyrighted this view in 1914. Dr. and Mrs. Philip T. Schley own the house today.

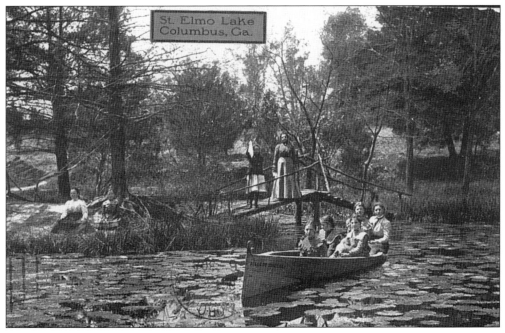

St. Elmo Lake
Columbus, Ga.

ST. ELMO PARK. This lake is immediately behind or east of the St. Elmo house and can be seen today from Cherokee Avenue.

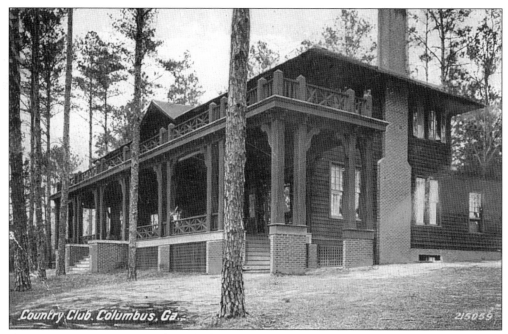

COLUMBUS COUNTRY CLUB. This club, shown here in 1912, was the first building out of three built at or near the club's current location of 2610 Cherokee Avenue. Built *c.* 1909, it was established on the Louis F. Garrard property and has always been a private club. This clubhouse burned around 1919.

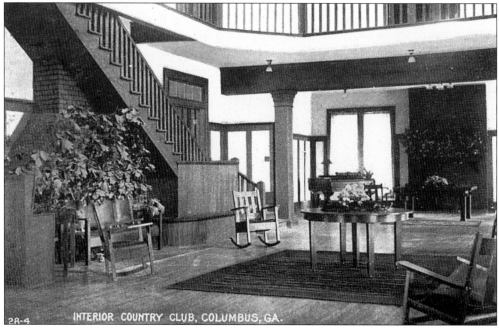

COLUMBUS COUNTRY CLUB INTERIOR. This is a *c.* 1913 interior view of the entry hall to the *c.* 1909 club, which stood until it burned around 1919.

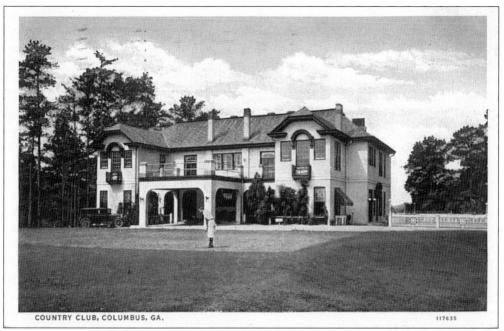

COLUMBUS COUNTRY CLUB. This 1938 view shows the second clubhouse on this site. The building was designed *c.* 1920 by Hickman and Martin, local architects. It stood here until the late 1940s when the present clubhouse replaced it. Note the golfer in front.

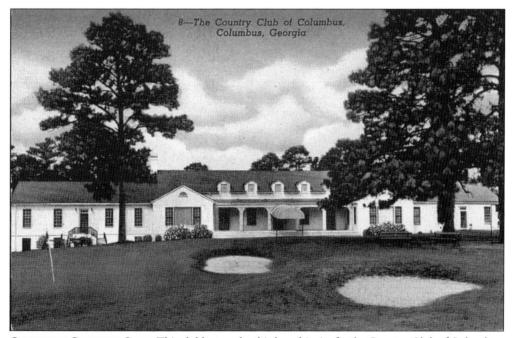

COLUMBUS COUNTRY CLUB. This clubhouse, the third on this site for the Country Club of Columbus, opened in 1948. It remains an active private club on a 110-acre site that includes a golf course, a swimming pool, tennis courts, as well as a restaurant and meeting space for members.

ALAMO PLAZA HOTEL COURT. This motel was built in 1940 by W.P. "Bobby" and Mary Wade Robinson at 2100 Buena Vista Road, the northeast corner with Brown Avenue. It had 43 units, a tea room and coffee shop. It joined the national franchise in the early 1950s. Owners until 1964, the Robinsons hosted many military figures, most notably Admiral Chester Nimitz. The site is now a strip shopping center. (Courtesy of Mary Wade Robinson.)

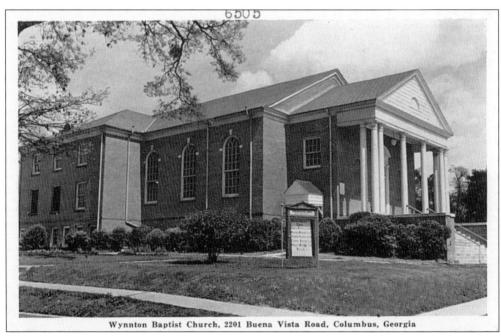

Wynnton Baptist Church, 2201 Buena Vista Road, Columbus, Georgia

WYNNTON BAPTIST CHURCH. Located at 2201 Buena Vista Road, a block east of the Alamo Plaza, the congregation dedicated this sanctuary in 1940. The congregation moved to a new location off River Road in the 1980s and is now Wynnbrook Baptist Church. This building, along with the other church buildings here, is now used by another faith. (Courtesy of Mike Helms.)

Seven
FORT BENNING

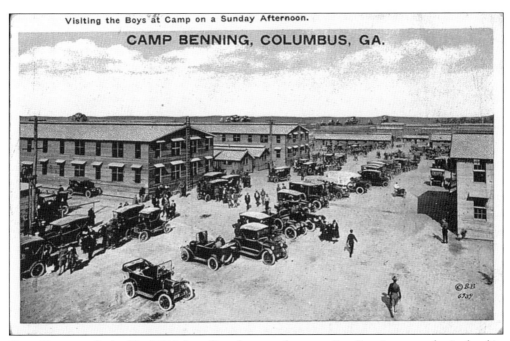

Visiting the Boys at Camp on a Sunday Afternoon.

CAMP BENNING, COLUMBUS, GA.

CAMP BENNING. In the fall of 1918 the military base now known as Fort Benning was authorized and its first location was on Macon Road, just past Wynnton. By 1919 it had moved to its location today with the Main Post buildings being in Chattahoochee County. This card, mailed in September 1920, shows the early barracks. In 1922 the post was renamed Fort Benning for Gen. Henry L. Benning, a Civil War general and judge from Columbus.

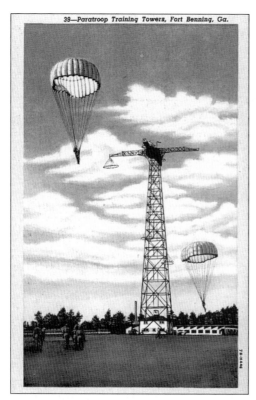

39—Paratroop Training Towers, Fort Benning, Ga.

JUMP TOWERS. The three parachute training towers on post, one of which is shown here *c.* 1947, have long been familiar symbols of the army base. The three are located on Main Post southwest of the Infantry School Building.

INFANTRY SCHOOL GREETINGS. This card, issued by the Curt Teich Co., a major postcard publisher, incorporates many symbols of Fort Benning. All the images within the letters also appeared on separate cards, as well as together in foldout multiple card souvenir folders.

INFANTRY SCHOOL, OFFICERS' CLUB, AND POST CHAPEL. This 1935 aerial view, mailed in 1937, shows the juxtaposition of three of the most well-known buildings on post. Doughboy Stadium can be seen just behind the chapel. This view is looking northwest.

Infantry School Building, Ft. Benning, Ga.

INFANTRY SCHOOL BUILDING. The headquarters for the Infantry School, shown here in 1938, was built in 1935 and designed by McKim, Mead, and White, a nationally known architectural firm. The memorial monument in the foreground to Calculator, a dog who died August 29, 1923, reads "He Made Better Dogs of us All." It has been moved to the National Infantry Museum. This building, now called Ridgeway Hall, is the location for the Western Hemisphere Institute for Security Cooperation.

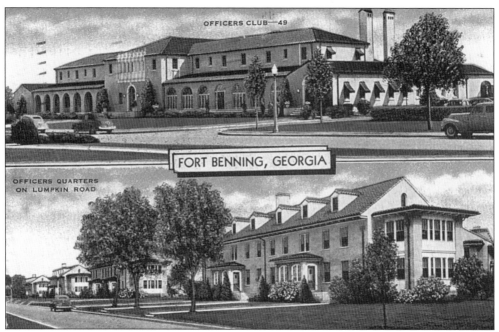

OFFICERS' CLUB AND OFFICERS' QUARTERS. The Officers' Club was completed in 1934 and was built on an axis with the Infantry School Building. These officers' quarters are duplexes and are still in use on Lumpkin Road. (Courtesy of the Historic Columbus Foundation.)

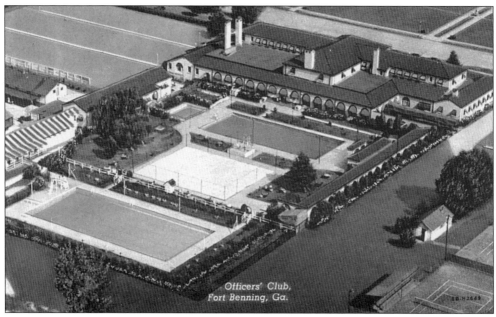

OFFICERS' CLUB. This *c.* 1946 view of the club shows the various additions following the 1935 view on the previous page. The first swimming pool was added in 1937, along with a formal garden. Lorin D. Raines of Columbus prepared the working drawings. The club is still in use as the Officers' Club.

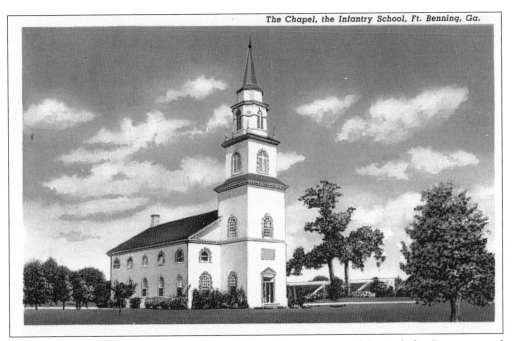

POST CHAPEL. This chapel was completed in April 1935 for the use of the Catholic, Protestant, and Jewish faiths. Columbus native Philip Trammell Shutze designed this Georgian Colonial Revival-style building for his firm, Hentz, Adler, and Shutze, of Atlanta. The chapel, which seats 400, is still in use.

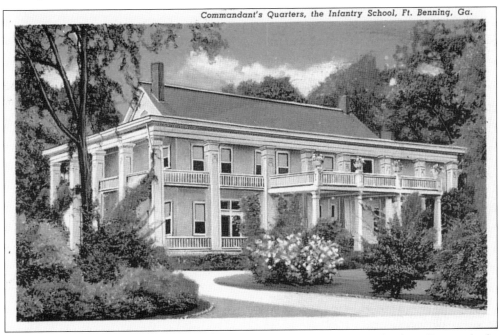

RIVERSIDE. The commanding general's home, known as Quarters Number One and the Commandant's Quarters, was built in 1909 for Arthur Bussey of Columbus. When the Army decided to move Camp Benning to a more permanent site, Bussey's Plantation was secured in 1919, one of many properties that created the 97,000-acre post, expanded after 1941 to over 180,000 acres.

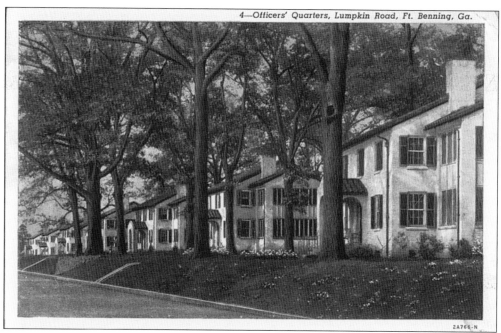

2A766-N

OFFICERS' QUARTERS, LUMPKIN ROAD. These houses shown *c*. 1932 were built between 1929 and 1932 for officers and are still in use today. They are northeast and just across the road from Riverside.

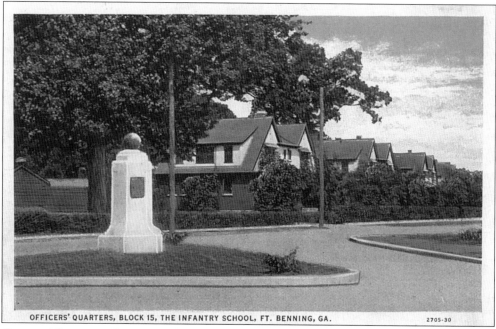

OFFICERS' QUARTERS, BLOCK 15, THE INFANTRY SCHOOL, FT. BENNING, GA.

2705-30

OFFICERS' QUARTERS, BLOCK 15. These Dutch Colonial Revival-style duplexes shown *c*. 1930 were the first permanent officers' housing, built in 1923–1924. They survive today along Austin Loop, Eames Avenue, and adjoining streets. The DAR and the UDC dedicated the monument in the median in 1929, honoring LaFayette's 1825 trip through the area, the Federal Road, the Indian village of Kasihta, and the Battle of Hichiti.

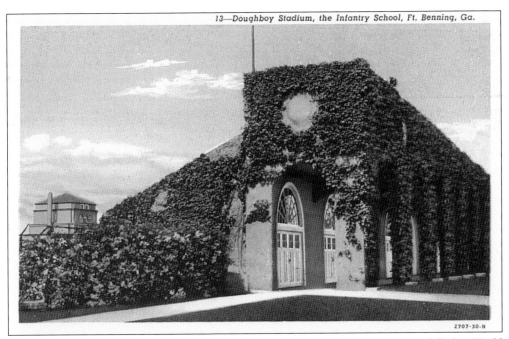

13—Doughboy Stadium, the Infantry School, Ft. Benning, Ga.

2707-30-N

DOUGHBOY STADIUM. This stadium was built in 1929 as a memorial to infantrymen killed in World War I, with funds donated by infantrymen from around the world. Shown here around 1930, it is one of the oldest remaining buildings and is adjacent to Gowdy Field. (Courtesy of Mary Lewis Pierson.)

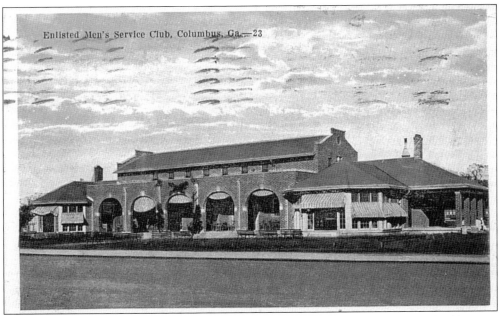

Enlisted Men's Service Club, Columbus, Ga.—23

ENLISTED MEN'S SERVICE CLUB. This card was mailed in 1923, the same year the building was completed. The club was adjacent to Doughboy Stadium and Gowdy Field on Ingersoll Street. Another postcard had the caption, "This club is the center of enlisted men's activities after duty hours. Various types of entertainment are provided for them at the club, such as dances, plays, musical recordings and concerts." It was demolished in the 1990s.

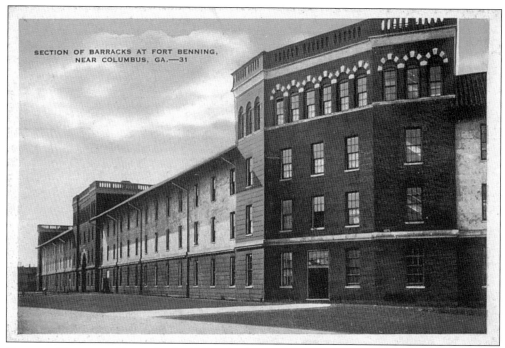

CUARTEL BARRACKS. Shown in the 1930s, this barracks was begun in 1927. *Cuartel* is Spanish for barracks. Built to house more than 2,000 men, the quadrangle created in the middle is more than 16 acres. The buildings are still in use. (Courtesy of Mary Lewis Pierson.)

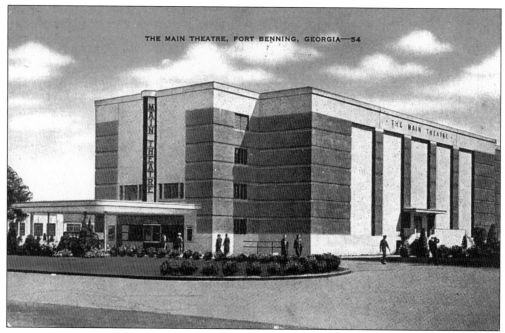

MAIN THEATER. Built in 1939, this building served as a movie house until it was torn down in the 1990s. It was located at the southwest corner of Wold Avenue and Ingersoll Street, south of the Enlisted Men's Club.

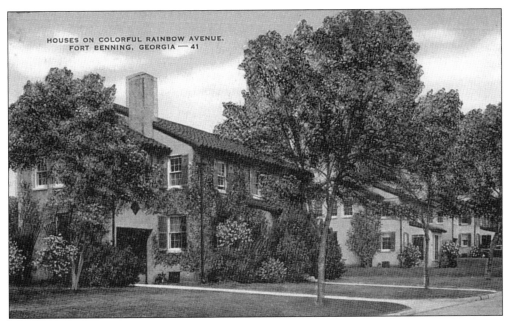

OFFICERS' QUARTERS, RAINBOW AVENUE. Built in 1932, these houses are still in use today and are each painted a different pastel color. They are located northeast of the Infantry School Building near the old hospital, now the National Infantry Museum.

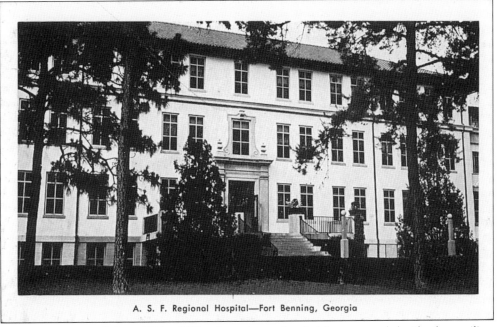

A. S. F. Regional Hospital—Fort Benning, Georgia

MAIN HOSPITAL. Built from 1924 to 1925 as the main post hospital, it was expanded with other auxiliary buildings nearby. It was placed on a hill for better ventilation for patients, as well as to be away from the rest of the post. Since 1959 it has been the National Infantry Museum. On the grounds are tanks, cannons, a train, and monuments, including the one to Calculator, formerly in front of the Infantry School Building.

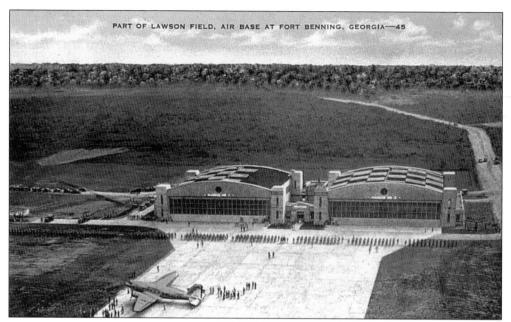

LAWSON FIELD HANGARS. These two hangars shown around 1940 still survive at Lawson Field, the air base portion of the post. The buildings, the oldest part of the larger Lawson Field, are located more than two miles southwest of the Infantry School Building. This view looks southwest.

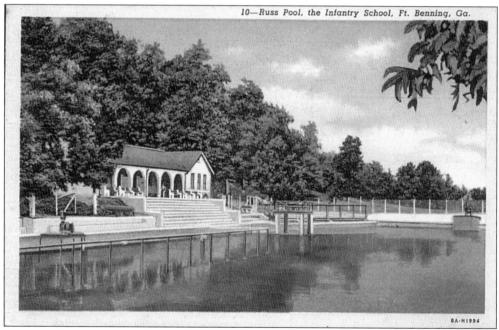

10—Russ Pool, the Infantry School, Ft. Benning, Ga.

8A-H1994

RUSS POOL. Russ Pool, or Russ Pond, shown in 1938, began in 1919 when a dam was built for a swimming hole. By 1926 there was a beach and concrete stands to hold 400, and the bathhouse was added in 1932. This was a favorite spot for enlisted personnel and their Columbus visitors. Although the bathhouse is gone, and the pool closed, the site remains a recreation spot. It is located on the north side of Main Post off Clark Road, near the Lumpkin Road entrance.

Eight

HERE AND THERE

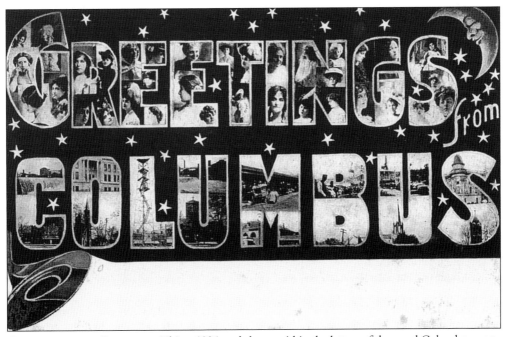

GREETINGS FROM COLUMBUS. This *c*. 1906 card shows within the letters of the word Columbus many views that appeared on the first view postcards published in 1905 and 1906. No publisher is listed. (Courtesy of the Historic Columbus Foundation, John Blackmar Collection.)

COLUMBUS, GEORGIA, "THE ELECTRIC CITY OF THE SOUTH."
Population, City and Suburbs 40,000 A Delightful and Healthy Climate.
All modern improvements—Schools, Churches, Paved Streets, Sewers, Water Works, Gas, Electricity,
Street Railway. An Ideal Tourist Resort, Social Clubs, Golf Links, Trap Shooting,
Fine Base Ball Grounds, Boating, Fishing, Transportation: Eight Lines of Railroad,
and Line of Steamers To The Gulf. Fine Location for Manufacturing Industries of all kinds,
Labor conditions exellent, Hydro Electric Power developed and being developed 90,000 H. P.

THE ELECTRIC CITY OF THE SOUTH. This *c.* 1910 view showcases one of the city's nicknames. The printed statement on the card lists many statistics and points of interest about the city. Perhaps the only claim that does not continue today is "Line of Steamers to the Gulf." (Courtesy of the Historic Columbus Foundation, Walter Wyatt Collection.)

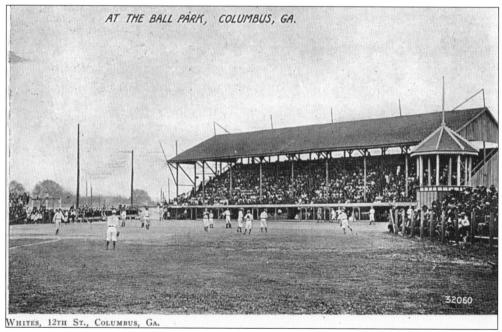

AT THE BALL PARK, COLUMBUS, GA.

WHITES, 12TH ST., COLUMBUS, GA.

AT THE BALL PARK. A local baseball team is on the field. This card was mailed in December 1910, having been printed for the White Company. (Courtesy of the Historic Columbus Foundation, Walter Wyatt Collection.)

120

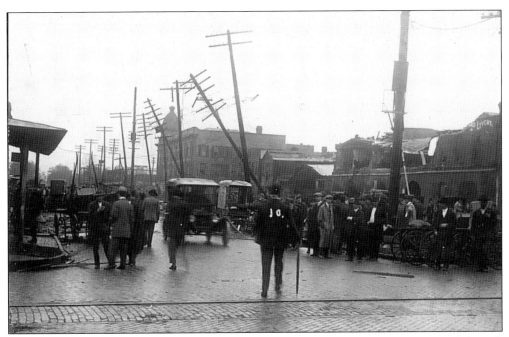

THE TORNADO OF 1913. A devastating tornado, or cyclone as it was called then, ripped through Columbus in the predawn hours of Friday, March 14, 1913. This view is looking south from Thirteenth Street down First Avenue toward the Columbus Investment Company (the Murrah/Empire Building) with its turret. The Southern Overall Company is at right. (Courtesy of Mary "Petey" Borders.)

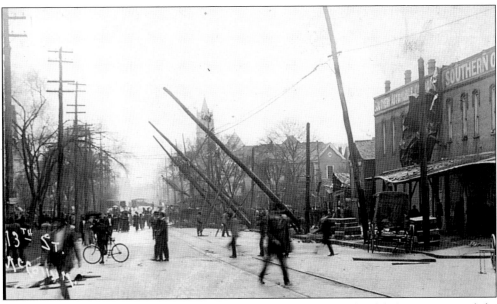

THE TORNADO OF 1913. Local photographers John B. McCollum and Ralph S. King captured the destruction in separate photo series, some of which were published in the two newspapers. Real photo postcards were made immediately, as one was mailed on March 18th. Many have been located in private collections during the research for this book. David Wallace, superintendent of the Eagle and Phenix Mills, once owned this one and the one above. (Courtesy of Mary "Petey" Borders.)

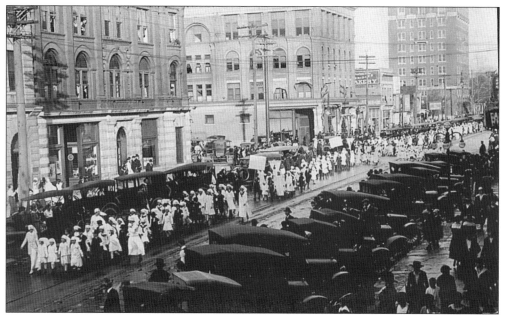

RED CROSS PARADE. This real photo postcard appears to be a Red Cross parade going west on Twelfth Street. As described in *Columbus on the Chattahoochee*, the women of the Red Cross planned several rallies, marches, and other events to show their support for the United States's decision to enter World War I on April 6, 1917. The exact event shown here has not been determined. (Courtesy of the Historic Columbus Foundation, Walter Wyatt Collection.)

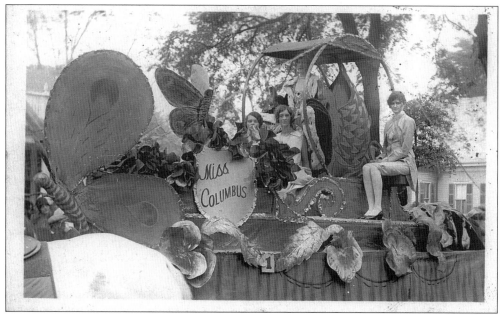

MISS COLUMBUS FLOAT 1928. A beauty contest was held as part of the Columbus Centennial Celebration of April 1928. Miss Dorothy Gloer was selected Miss Columbus and sits atop this float. Other beauty queens representing outlying towns and counties also participated. (Courtesy of Teresa Cole.)

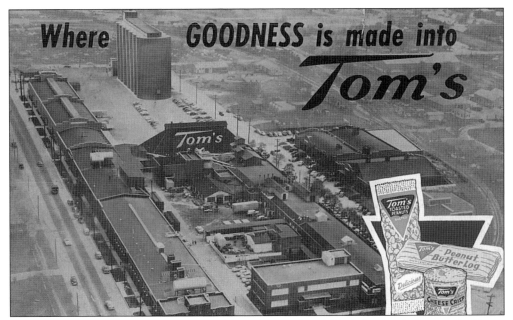

TOM HUSTON PEANUT COMPANY. One of the industries for which Columbus is famous, the Tom's facility along Tenth Avenue covers three city blocks. The card indicates that they processed 30 million pounds of choice peanuts yearly for Tom's Toasted Peanuts and other products. (Courtesy Mary Lewis Pierson.)

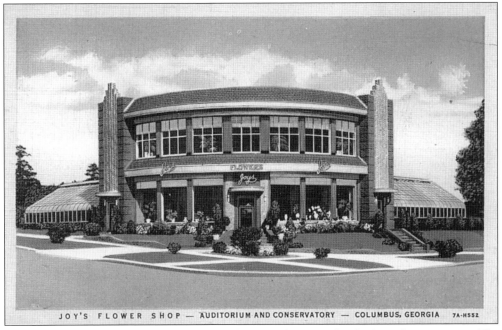

JOY'S FLOWER SHOP. This shop opened around 1940 and remained in business for many years. The building's unusual design, facing southwest the intersection of Thirteenth Avenue and Thirteen Street, made this card popular. The building survives today as the Sho-Place Inc., an interior design business.

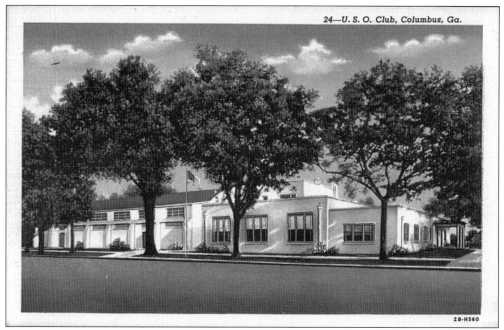

24—U. S. O. Club, Columbus, Ga.

2B-H560

THE U.S.O. CLUB. This building opened in May 1942, in downtown Columbus on the south side of Ninth Street, just across the street from the county courthouse. This card indicates that when it opened "It [was] one of the five largest of such clubs constructed in the United States." The site is now a parking lot.

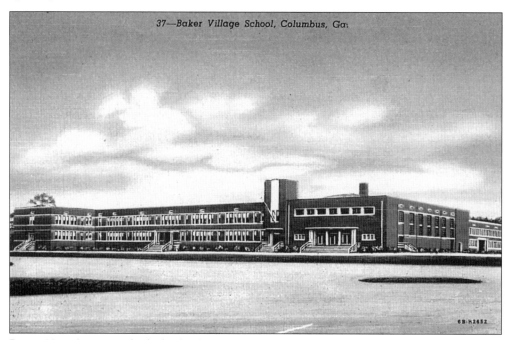

37—Baker Village School, Columbus, Ga.

6B-H2652

BAKER HIGH SCHOOL. This high school opened on September 15, 1943, at 1536 Benning Road, to serve the children of military families from Fort Benning. It remained a high school until recently and then became a middle school.

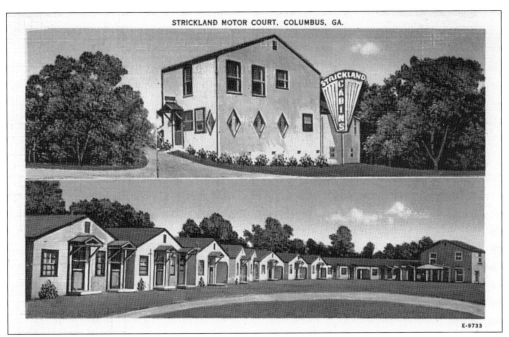

STRICKLAND MOTOR COURT. This early motel is similar to many that cropped up around Columbus during the 1930s and 1940s. This one was operated by Mr. and Mrs. John W. Strickland on US 27 and US 280, two miles south of the city, and was "adjacent to Fort Benning."

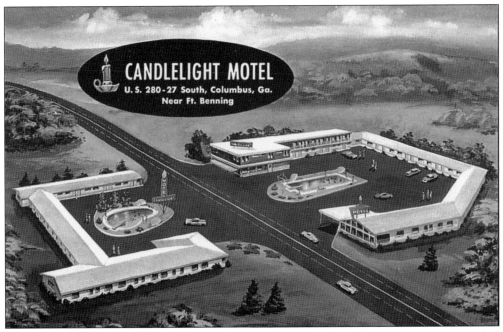

CANDLELIGHT MOTEL. This motel was near the one above and has the more modern look of a motel. It had a restaurant and two swimming pools. The motel is still in business at 3456 Victory Drive.

WRBL Radio. WRBL started in 1928 as the city's first radio station. The company moved to this building at 1350 Thirteenth Avenue in 1950 and are still operating a television station here. This card was printed while they were only radio. They began television broadcasting here on November 15, 1953. (Courtesy of Mike Helms.)

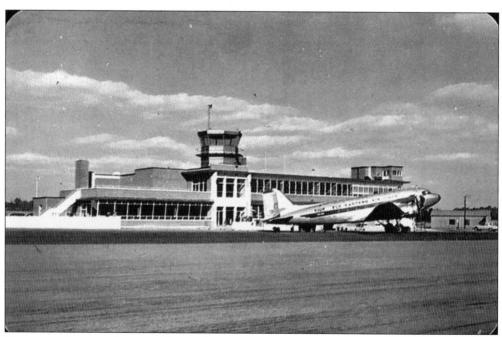

Muscogee County Airport. This card was mailed in 1951 and the caption indicates that this is the new $400,000 administration building at the new Moon Road/Britt David Road airport site. Three major airlines served Columbus then. The new building, proposed first in 1943, had been held up by war regulations and was not opened until December 1950. The plane is from Eastern Air Lines.

BIBLIOGRAPHY

A great deal of information can be found throughout all of the collections in the Archives at Columbus State University's Library, but none of these are specifically cited here.

Autry, Dolores. *Linwood Cemetery, Columbus, Georgia*. 1994. (This book exists only in a few photocopies but is an invaluable source in documenting Columbus citizens.)

Historic Preservation Division, Georgia Department of Natural Resources, Atlanta. National Register of Historic Places and Identified Sites Files, including the Fort Benning survey, as well as the Muscogee County Clippings, and material on specific Georgia Architects.

Kyle, F. Clason. *Images: A Pictorial History of Columbus, Georgia*. Norfolk, VA: The Donning Co., 1986.

Lupold, John S. *Columbus, Georgia, 1828-1978*. Columbus: Columbus Sesquicentennial, Inc., 1978.

Lupold, John S. *Chattahoochee Valley Sources & Resources: An Annotated Bibliography, Volume II: The Georgia Counties*. Eufaula, AL: Historic Chattahoochee Commission, 1993.

Mahan, Joseph B. *Columbus: Georgia's Fall Line "Trading Town."* Northridge, CA: Windsor Publications, 1986.

Mahan, Katherine Hines. *Showboats to Soft Shoes: A Century of Musical Development in Columbus, Georgia, 1828-1928*. Columbus: Columbus Office Supply Co., 1968.

Muscogiana, the journal of the Muscogee Genealogical Society. (Begun in 1989, this ongoing periodical has included cemetery records and history articles that are good sources about the city.)

Reid, Edge, comp. *Ledger References, 1916-1970; Enquirer References , 1950-1970*. (A typescript, it is a valuable index to important local headlines, events, and building news.)

Sanborn Fire Insurance Maps. The 1907 and 1929 maps were the most useful to this book The maps are incredibly detailed records of the existence of buildings and their locations.

Telfair, Nancy [Louise Gunby Jones DuBose]. *A History of Columbus, Georgia, 1828-1928*. Columbus: Historical Publishing Co., 1929.

Whitehead, Margaret Laney and Barbara Bogart. *City of Progress: A History of Columbus, Georgia*. Columbus: Columbus Office Supply Co., 1978.

Woodall, W.C. *Columbus Magazine*. (A magazine issued only for a few years as a quarterly in the 1940s. Good source for specific buildings. There is a separate index.)

Woodall, W.C. *The Industrial Index*. (A magazine published starting in 1906 through the 1950s. Copies at Columbus State University and the W.C. Bradley Library. An index to its Columbus photographs also exists and is a valuable tool to finding specifics on Columbus buildings and events.)

Worsley, Etta Blanchard. *Columbus on the Chattahoochee*. Columbus: Columbus Office Supply Co., 1951.

INDEX